Draw 50 Athletes

OPRL MILLER

Other Doubleday books by Lee J. Ames:

DRAW 50 ANIMALS

DRAW 50 BOATS, SHIPS, TRUCKS AND TRAINS

DRAW 50 DINOSAURS AND OTHER PREHISTORIC ANIMALS

DRAW 50 AIRPLANES, AIRCRAFT AND SPACECRAFT

DRAW 50 FAMOUS FACES

DRAW 50 FAMOUS CARTOONS

DRAW 50 VEHICLES

DRAW 50 BUILDINGS AND OTHER STRUCTURES

DRAW 50 DOGS

DRAW 50 FAMOUS STARS

DRAW 50 MONSTERS, CREEPS, SUPERHEROES, DEMONS, DRAGONS, NERDS, DIRTS, GHOULS, GIANTS, VAMPIRES, ZOMBIES, AND OTHER CURIOSA . . .

DRAW 50 HORSES

Lee J. Ames

Doubleday New York London Toronto Sydney Auckland Published by Doubleday, a division of Bantam Doubleday Dell Publishing Group, Inc. 666 Fifth Avenue, New York, New York 10103

Doubleday and the portrayal of an anchor with a dolphin are trademarks of Doubleday, a division of Bantam Doubleday Dell Publishing Group, Inc.

Library of Congress Cataloging-in-Publication Data: Ames, Lee J.

Draw 50 athletes.

Summary: Step-by-step instructions on how to draw a variety of athletes from a number of action perspectives.

1. Action in art—Juvenile literature. 2. Athletes in art—Juvenile literature. 3. Wrestlers in art—Juvenile literature. 4. Drawing—Technique—Juvenile literature. [1. Athletes in art. 2. Drawing—Technique] I. Title. II. Title: Draw fifty athletes.

NC785.A46 1985 743'.4 83-45569
ISBN 0-385-19055-7
ISBN 0-385-19056-5 (lib. bdg.)
ISBN 0-385-24638-2 (pbk.)

Text and illustrations copyright © 1985 by Lee J. Ames and Murray D. Zak

ALL RIGHTS RESERVED
PRINTED IN THE UNITED STATES OF AMERICA

To Jonathan and Cindy, my favorite athletes, with much love . . .

... and thanks to Warren Budd for all his help.

To the Reader

This book of 50 athletes will show you a method of drawing the human figure, of searching out the basic simple forms and lightly building one on the other. When these forms add up to a complete figure, drawn very lightly up to this point, the drawing is finished with firm, dark lines.

You need not start with the first illustration. Choose whichever you wish. When you have decided, follow the step-by-step method shown. *Very lightly* and *carefully*, sketch out step number one. However, this step, which is the easiest, should be done *most carefully*. Step number two is added right to step number one, also lightly and also very carefully. Step number 3 is sketched right on top of numbers one and two. Continue this way to the last step.

It may seem strange to ask you to be extra careful when you are drawing what seem to be the easiest first steps, but this is most important, for a careless mistake at the beginning may spoil the whole picture at the end. As you sketch out each step, watch the spaces between the lines, as well as the lines, and see that they are the same. After each step, you may want to lighten your work by pressing it with a kneaded eraser (available at art supply stores).

When you have finished, you may want to redo the final step in India ink with a fine brush or pen. When the ink is dry, use the kneaded eraser to clean off the pencil lines. The eraser will not affect the India ink.

Here are some suggestions: In the first few steps, even

when all seems quite correct, you might do well to hold your work up to a mirror. Sometimes the mirror shows that you've twisted the drawing off to one side without being aware of it. At first you may find it difficult to draw the egg shapes, or ball shapes, or sausage shapes, or just to make the pencil go where you wish. Don't be discouraged. The more you practice, the more you will develop control. The only equipment you'll need will be a medium or soft pencil, paper, the kneaded eraser and, if you wish, a pen or brush and India ink.

The first steps in this book are shown darker than necessary so that they can be clearly seen. (Keep your work very light)

Remember there are many other ways and methods to make drawings. This book shows just one method. Why don't you seek out other ways from teachers, from libraries and, most importantly . . . from inside yourself?

Lee J. Ames

To the Parent or Teacher

"Leslie can draw a soccer player better than anybody else!" Such peer acclaim and encouragement generate incentive. Contemporary methods of art instruction (freedom of expression, experimentation, self-evaluation of competence and growth) provide a vigorous, fresh-air approach for which we must all be grateful.

New ideas need not, however, totally exclude the old. One such is the "follow me, step-by-step" approach. In my young learning days this method was so common, and frequently so exclusive, that the student became nothing more than a pantographic extension of the teacher. In those days it was excessively overworked.

This does not mean that the young hand is never to be guided. Rather, specific guiding is fundamental. Step-by-step guiding that produces satisfactory results is valuable even when the means of accomplishment are not fully understood by the student.

The novice with a musical instrument is frequently taught to play simple melodies as quickly as possible, well before he learns the most elemental scratchings at the surface of music theory. The resultant self-satisfaction, pride in accomplishment, can be a significant means of providing motivation. And all from mimicking an instructor's "Do-as-I-do. . . ."

Mimicry is prerequisite for developing creativity. We learn the use of our tools by mimicry. Then we can use those tools for creativity. To this end I would offer the budding artist the opportunity to memorize or mimic (rotelike, if you wish) the making of "pictures." "Pictures" he has been eager to be able to draw.

The use of this book should be available to anyone who wants to try another way of flapping his wings. Perhaps he will then get off the ground when his friend says, "Leslie can draw a soccer player better than anyone else!"

Lee J. Ames

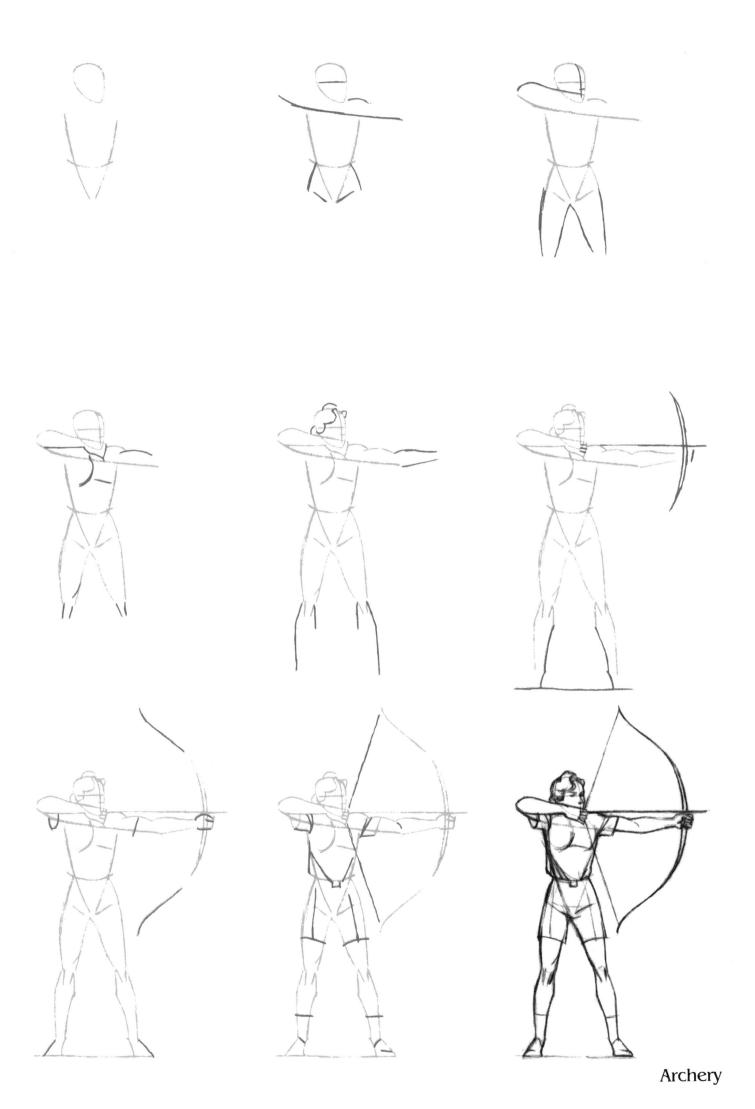

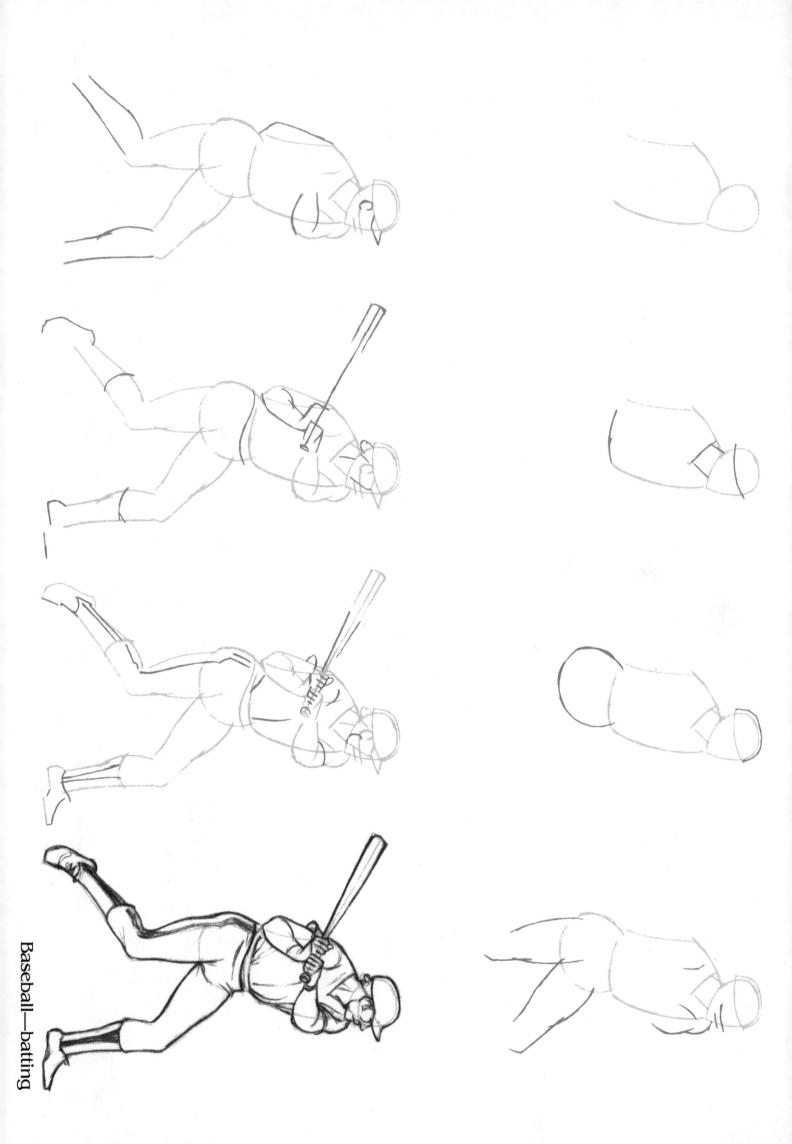

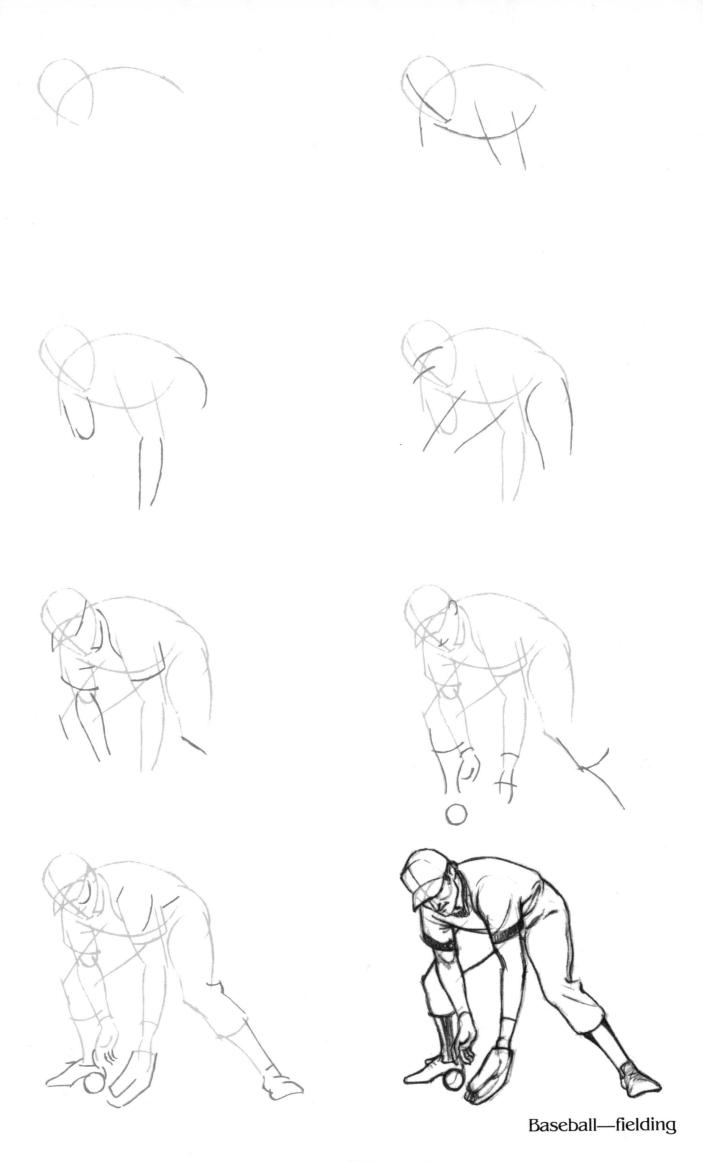

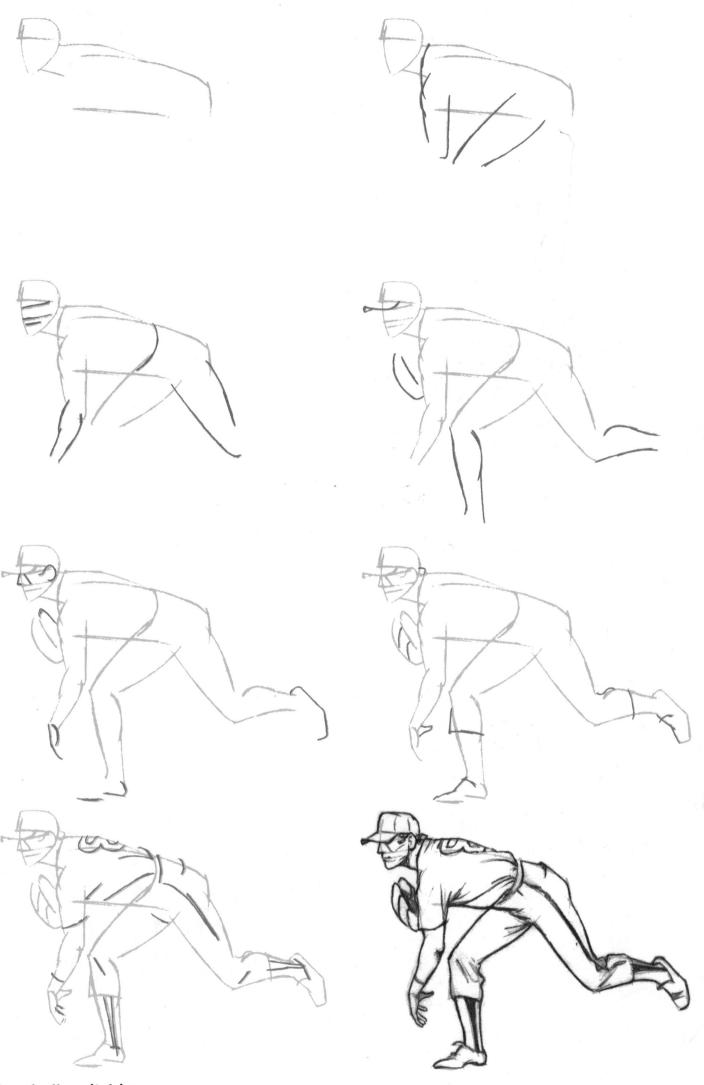

Baseball—pitching

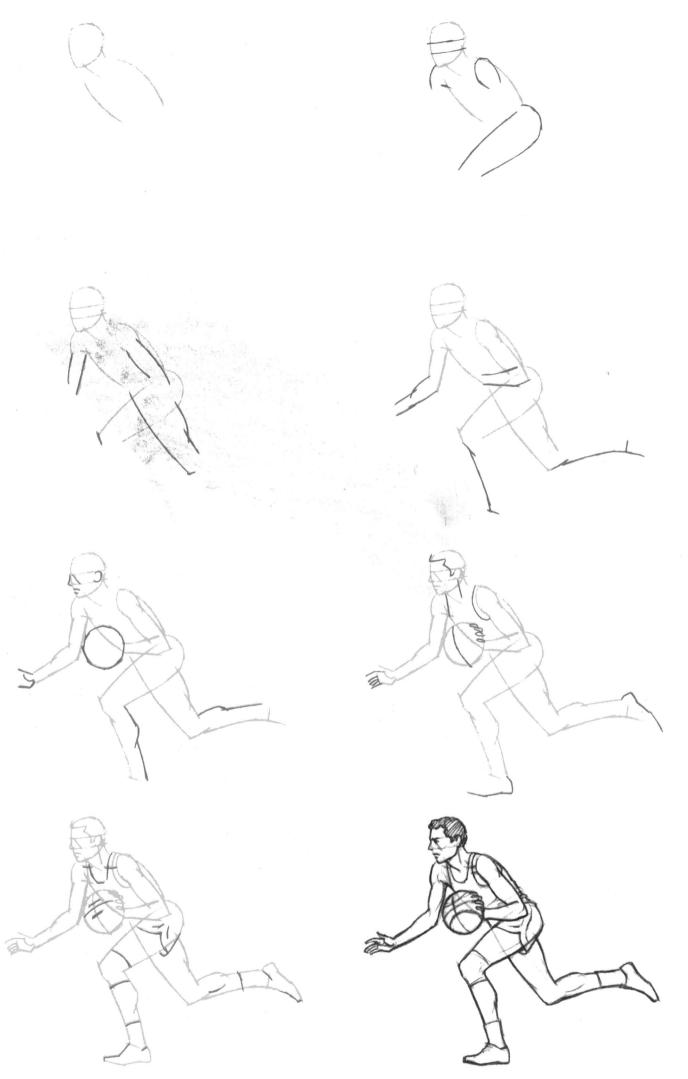

Basketball—dribbling

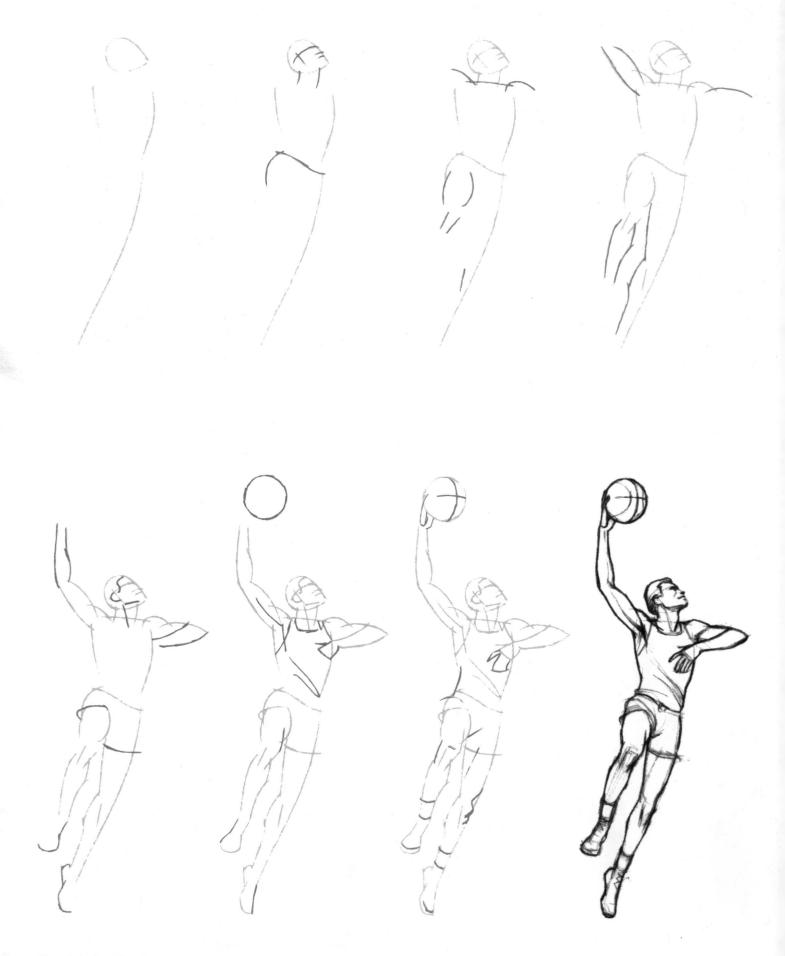

Basketball—hook shot

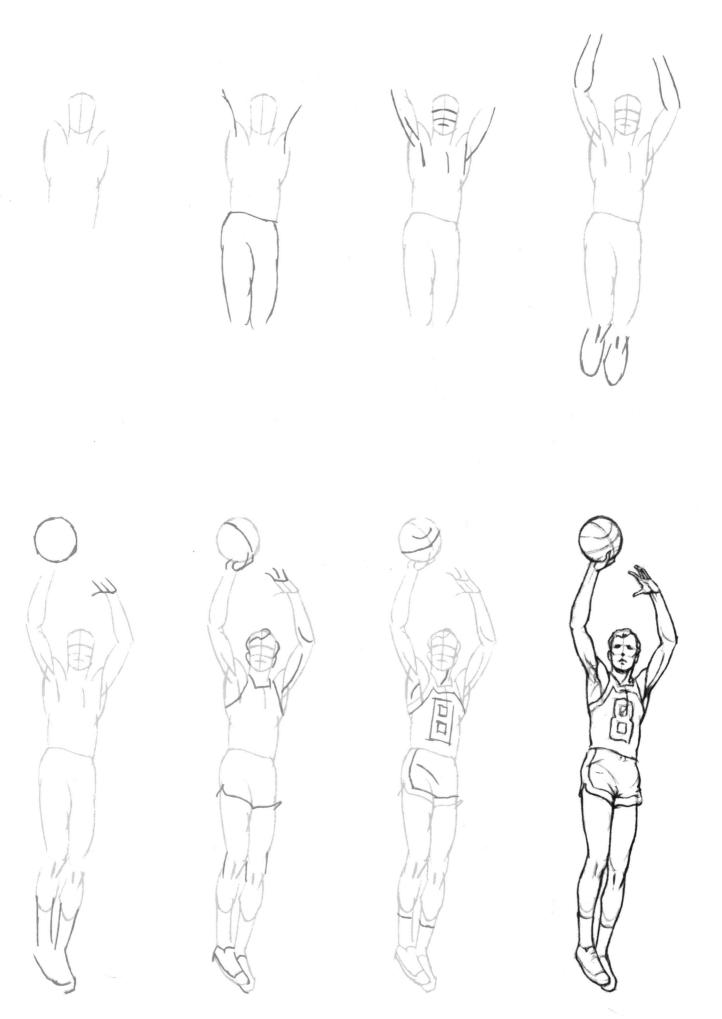

Basketball—jump shot

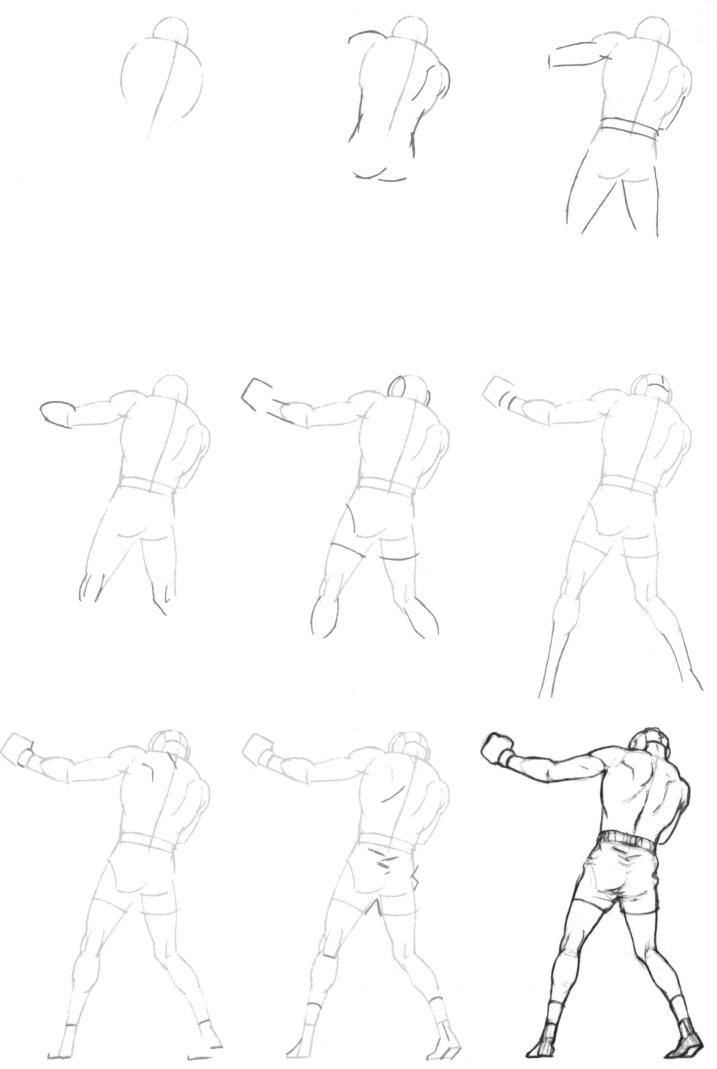

Boxing—left hook

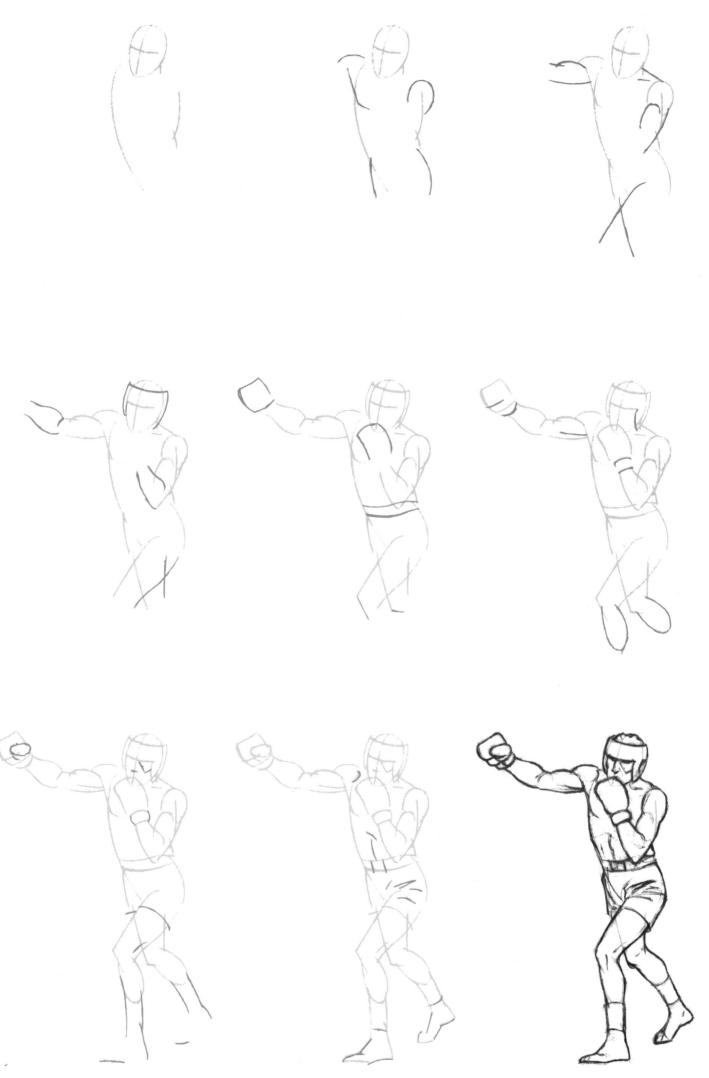

Boxing—right cross

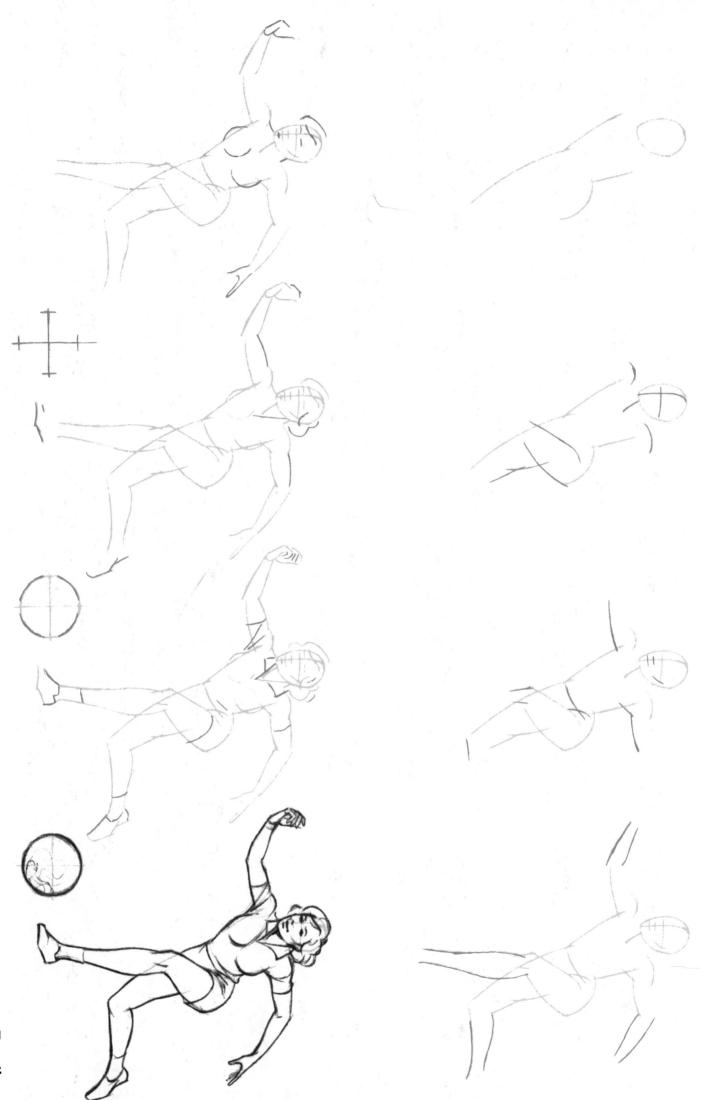

Bowling

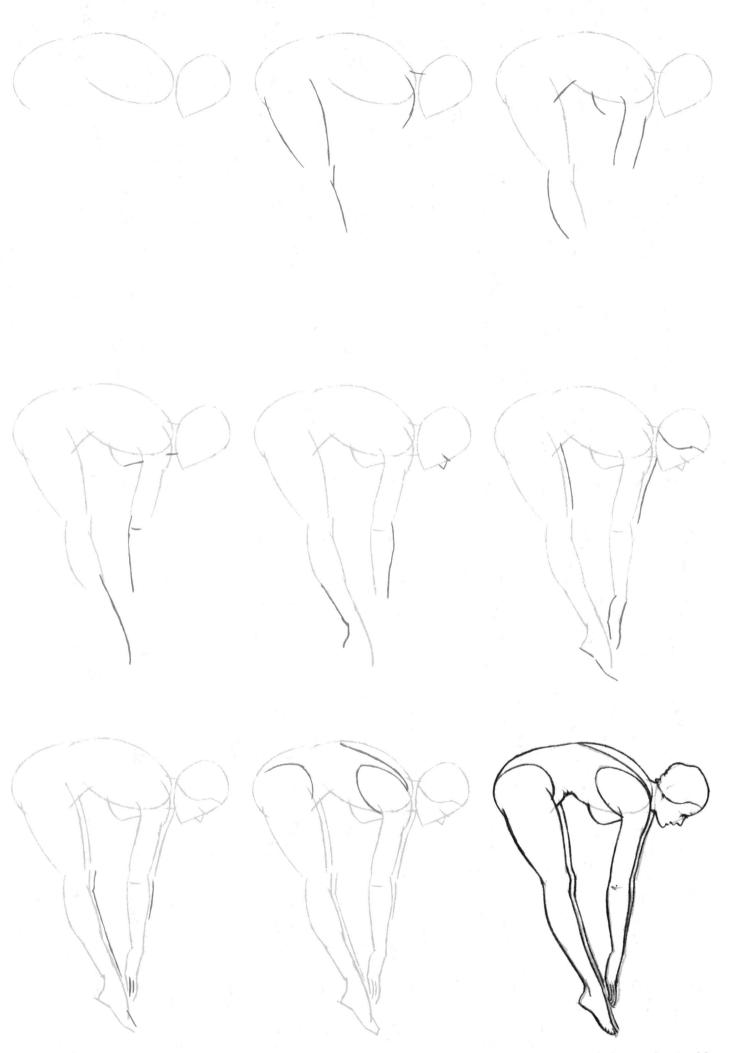

Diving—jacknife

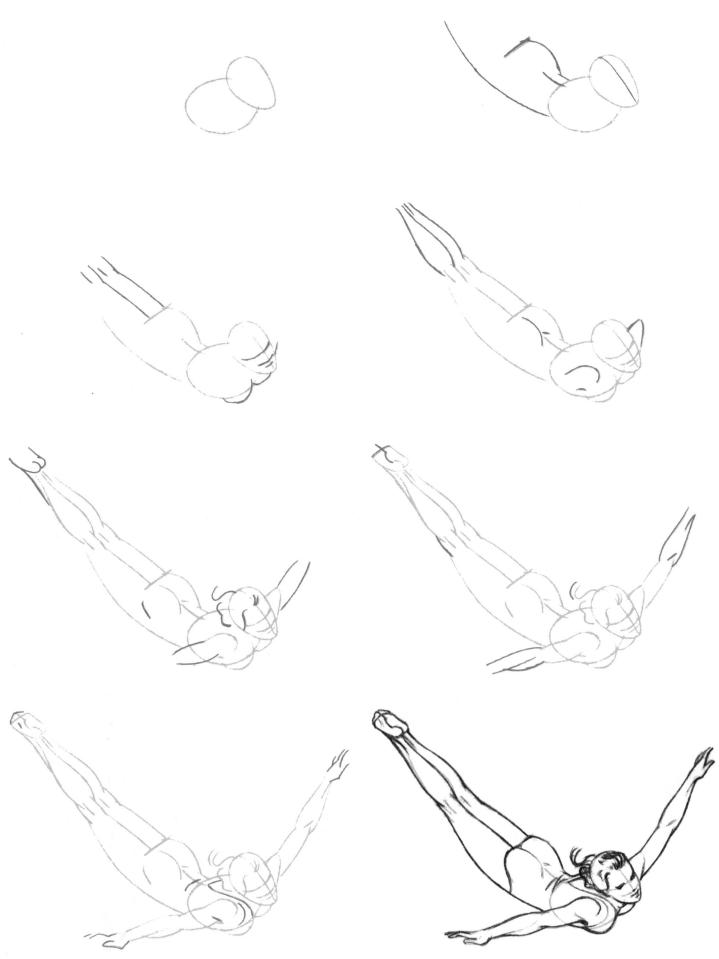

Diving—swan

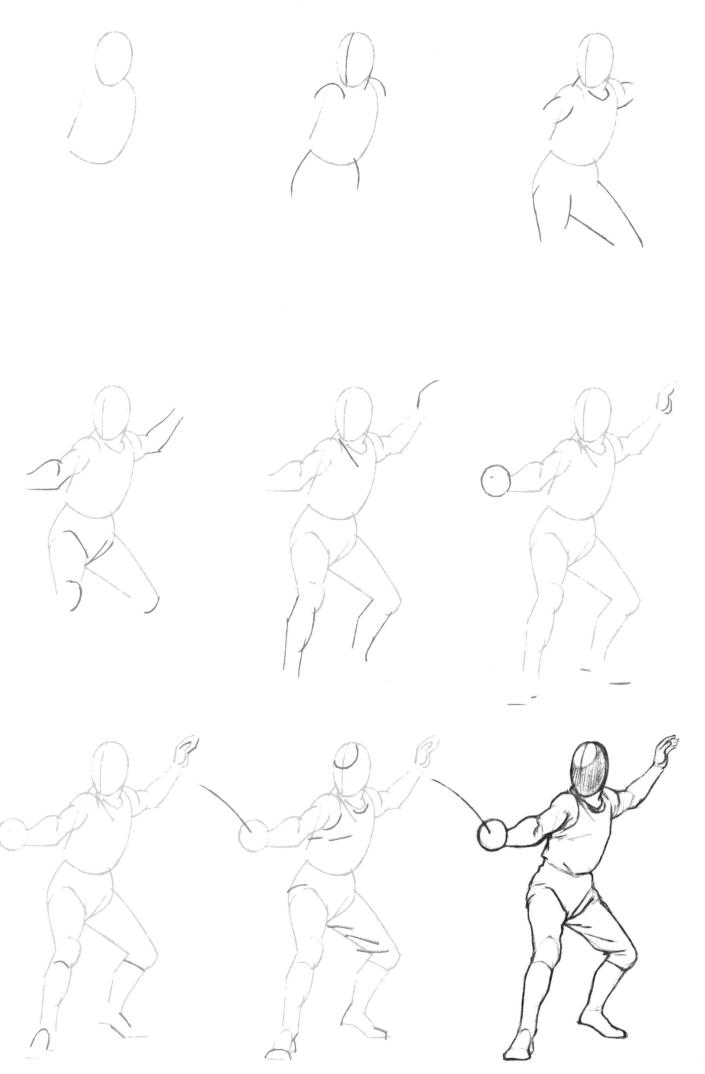

Fencing—en garde

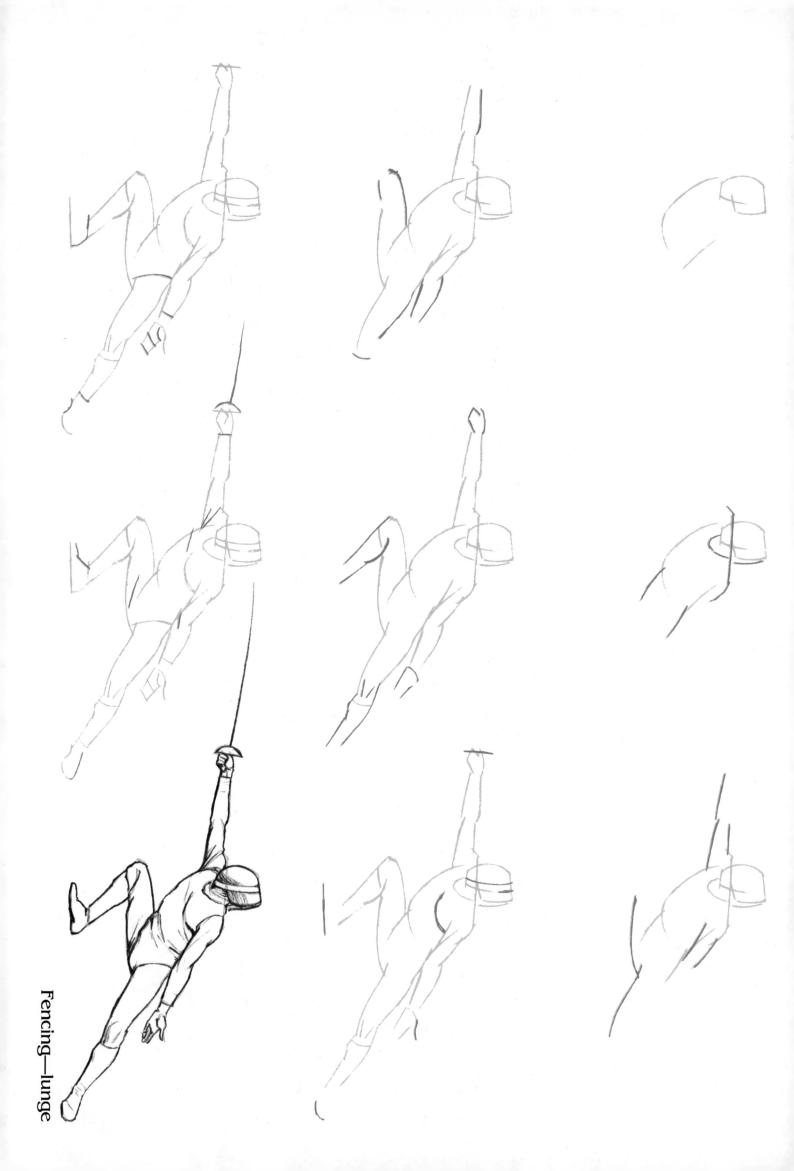

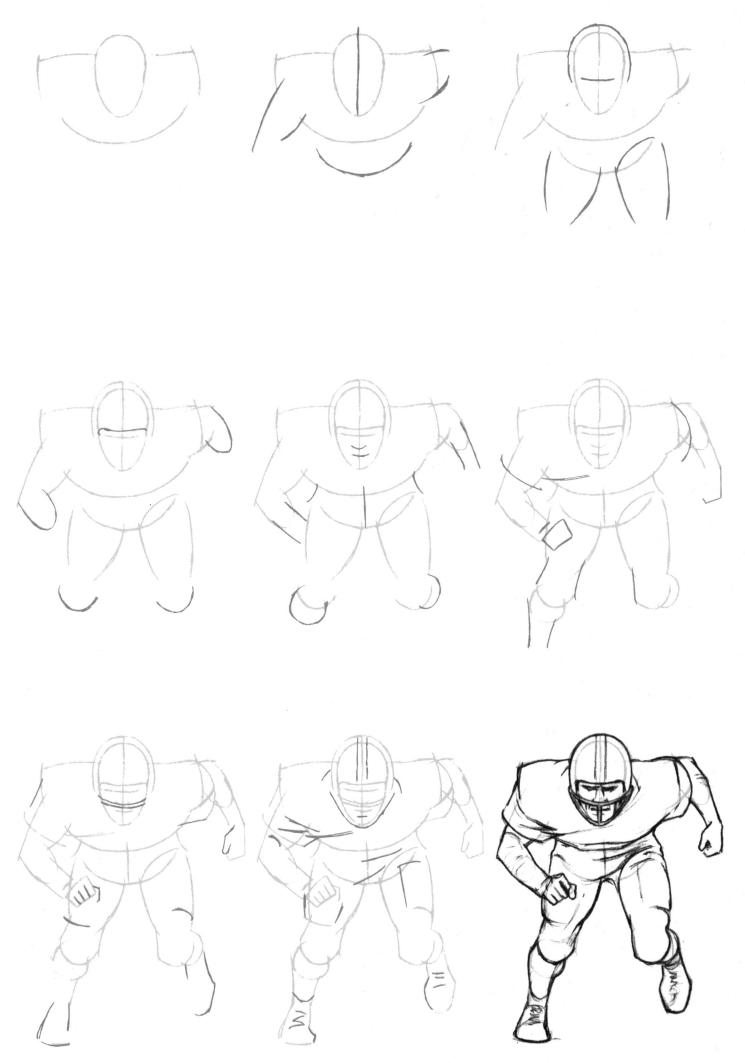

Football—linebacker

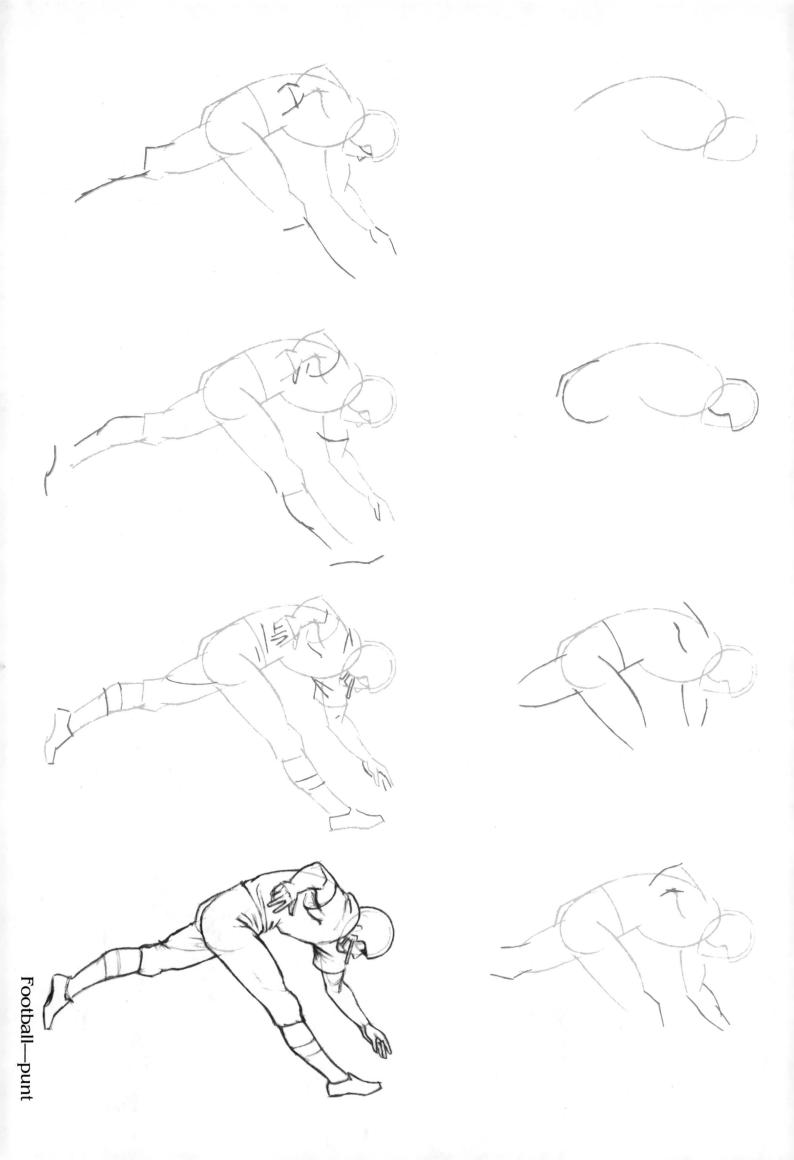

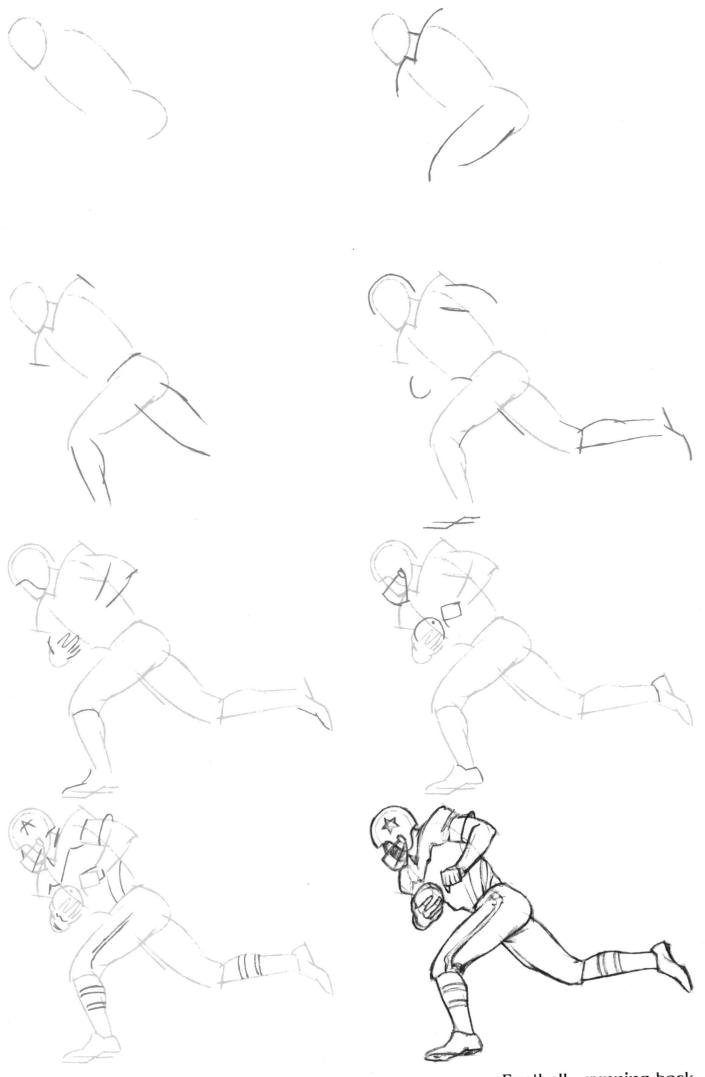

Football—running back

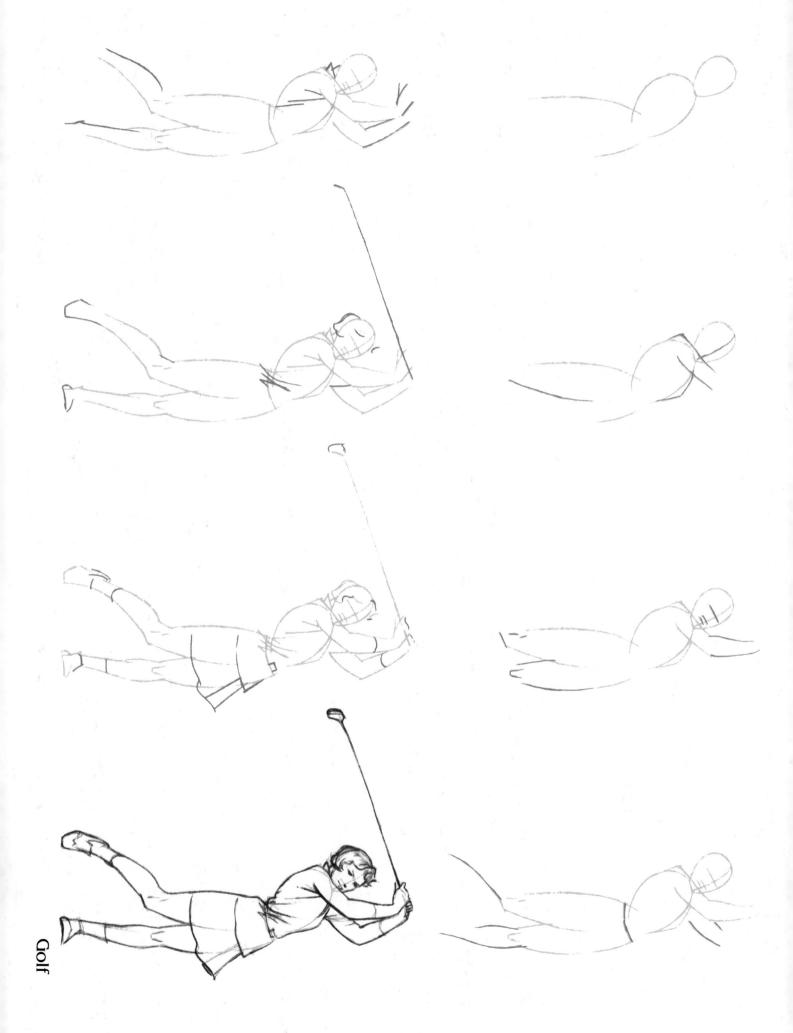

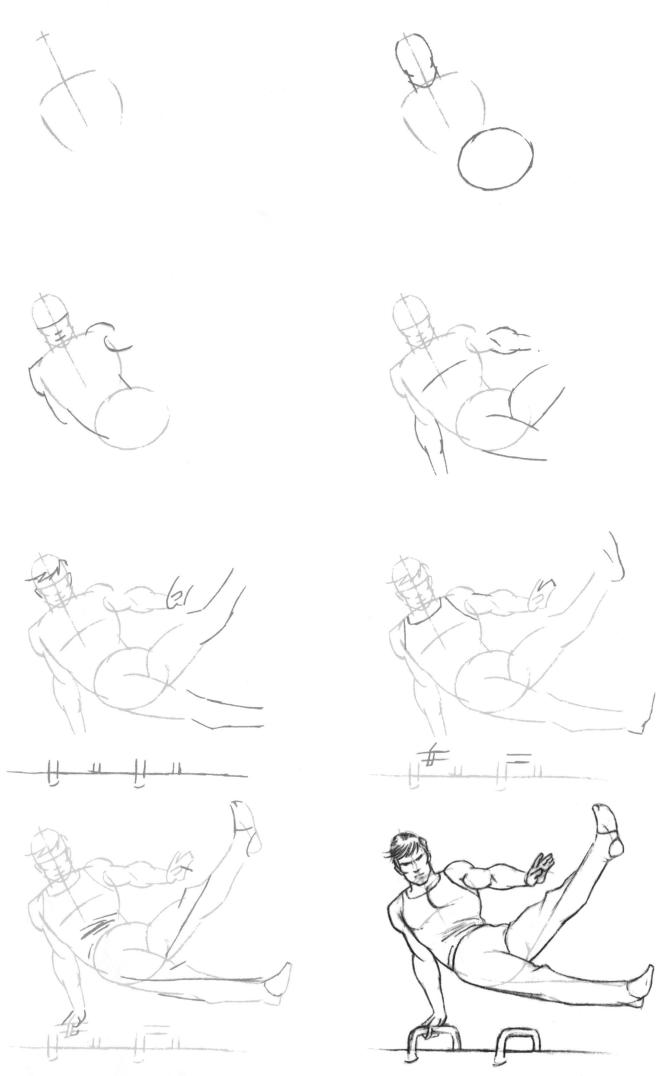

Gymnastics—pommel horse

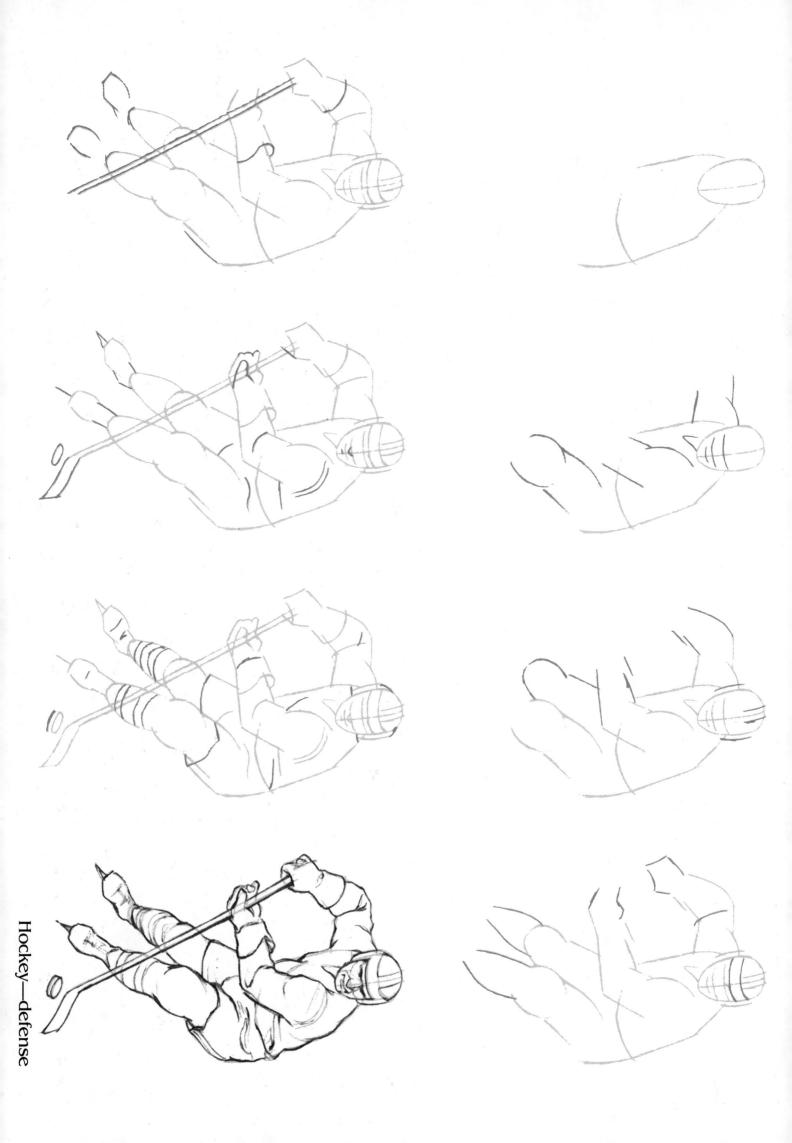

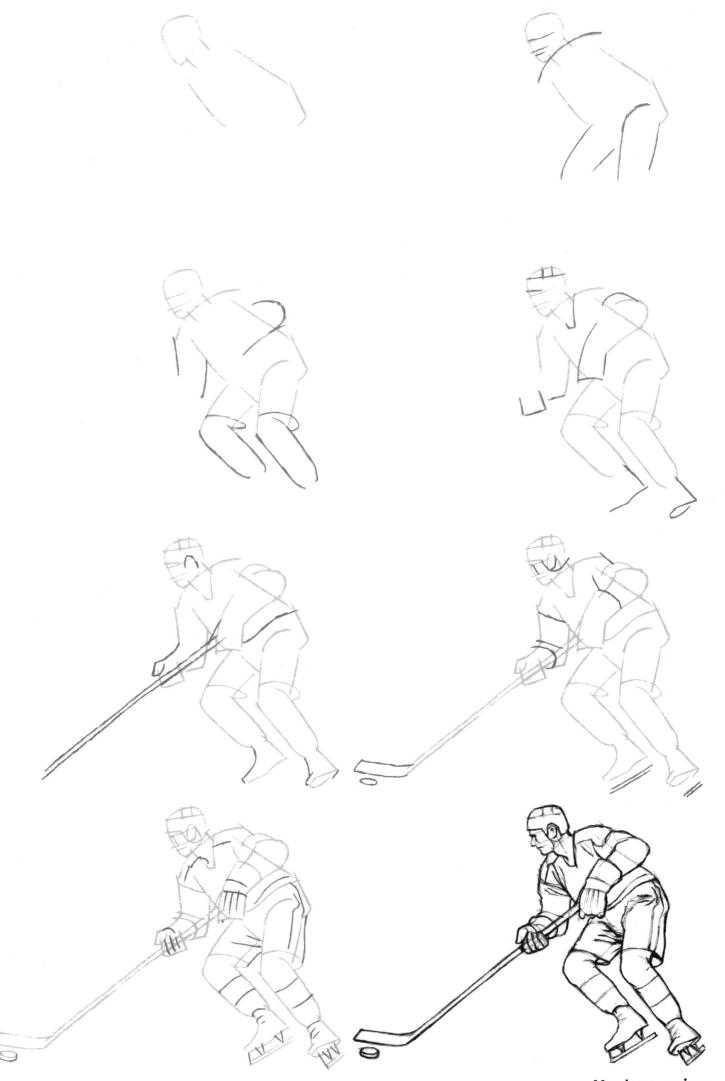

Hockey—wing

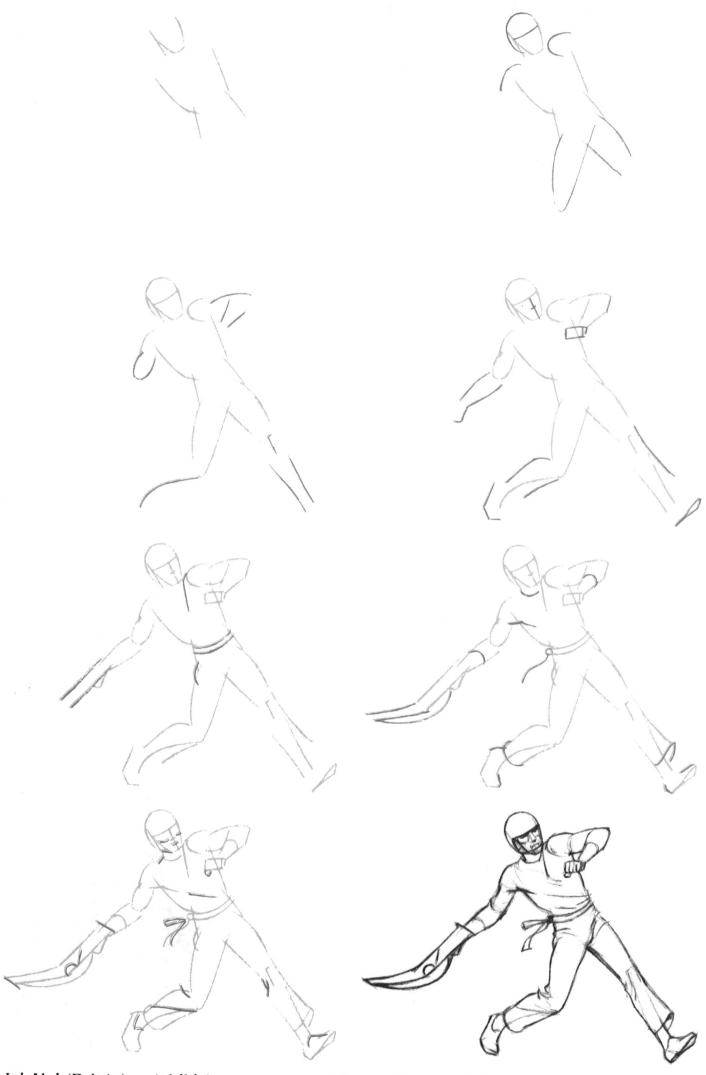

Jai Alai (Pelota)—atchiki (momentary holding of the pelote)

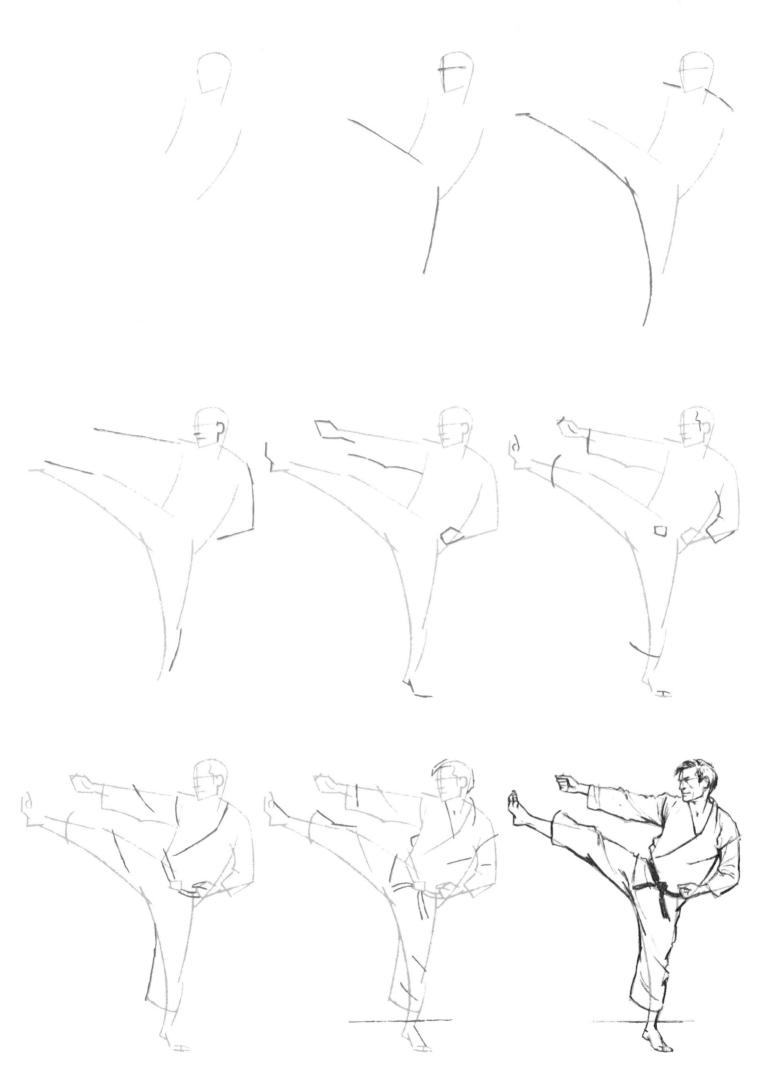

Karate—back fist & sword foot

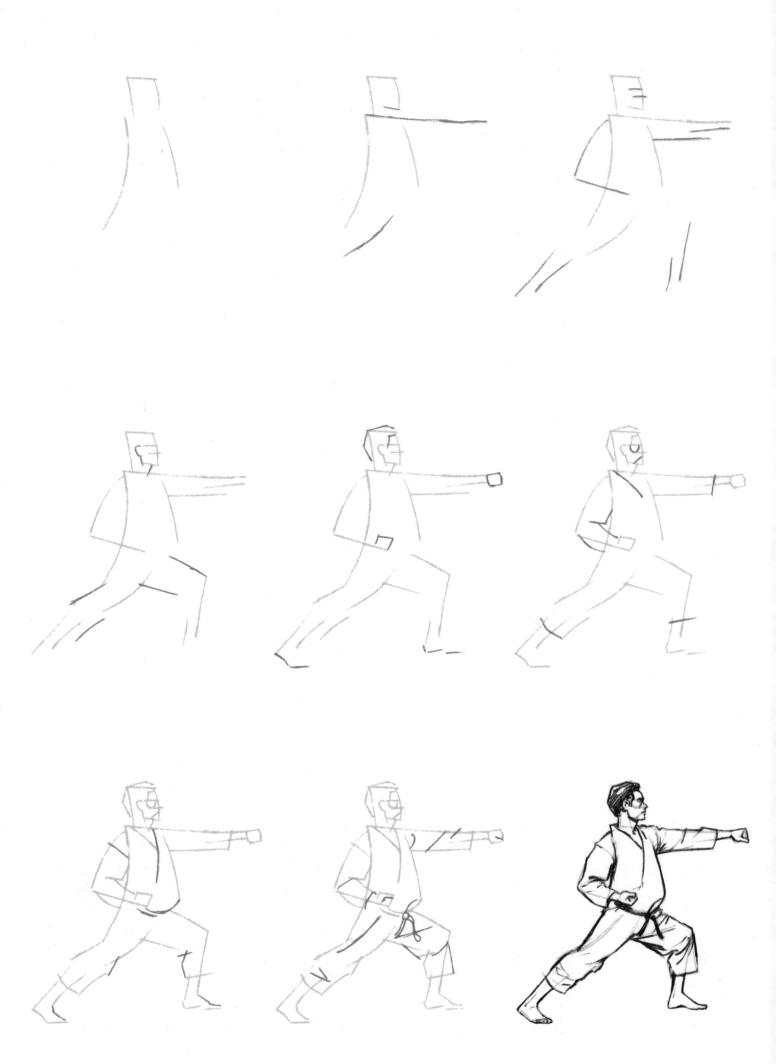

Karate—(middle level) front attack

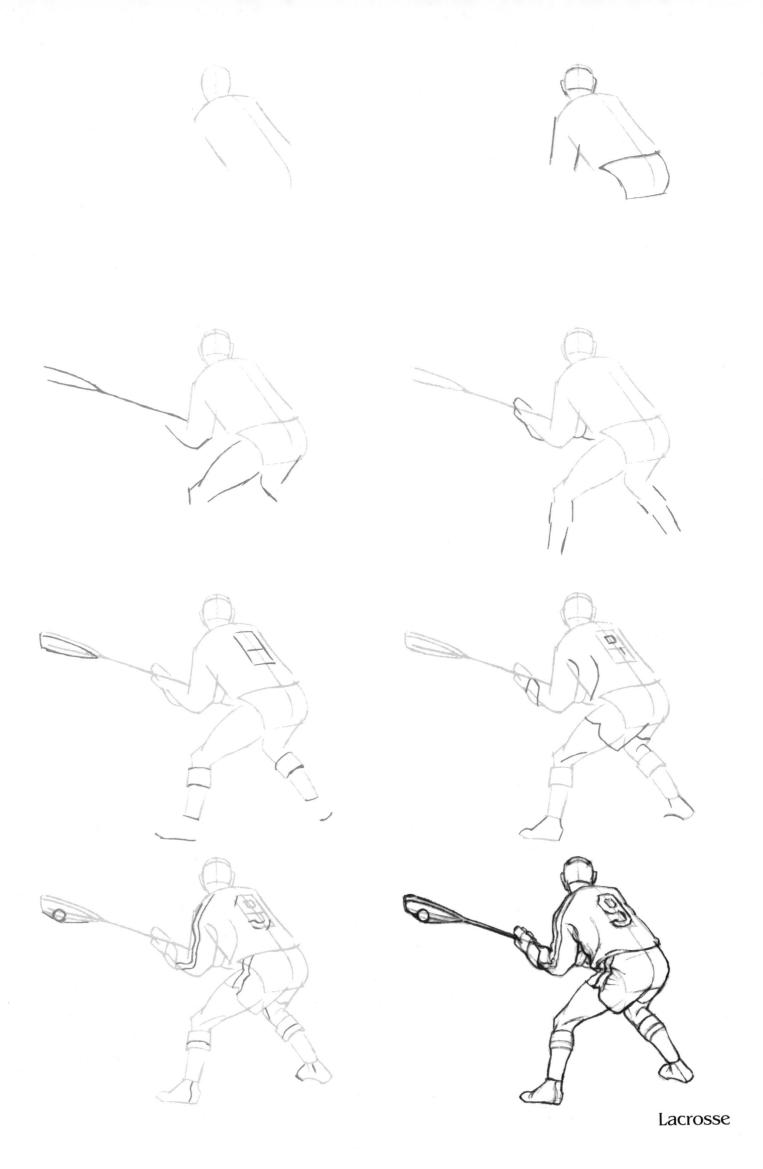

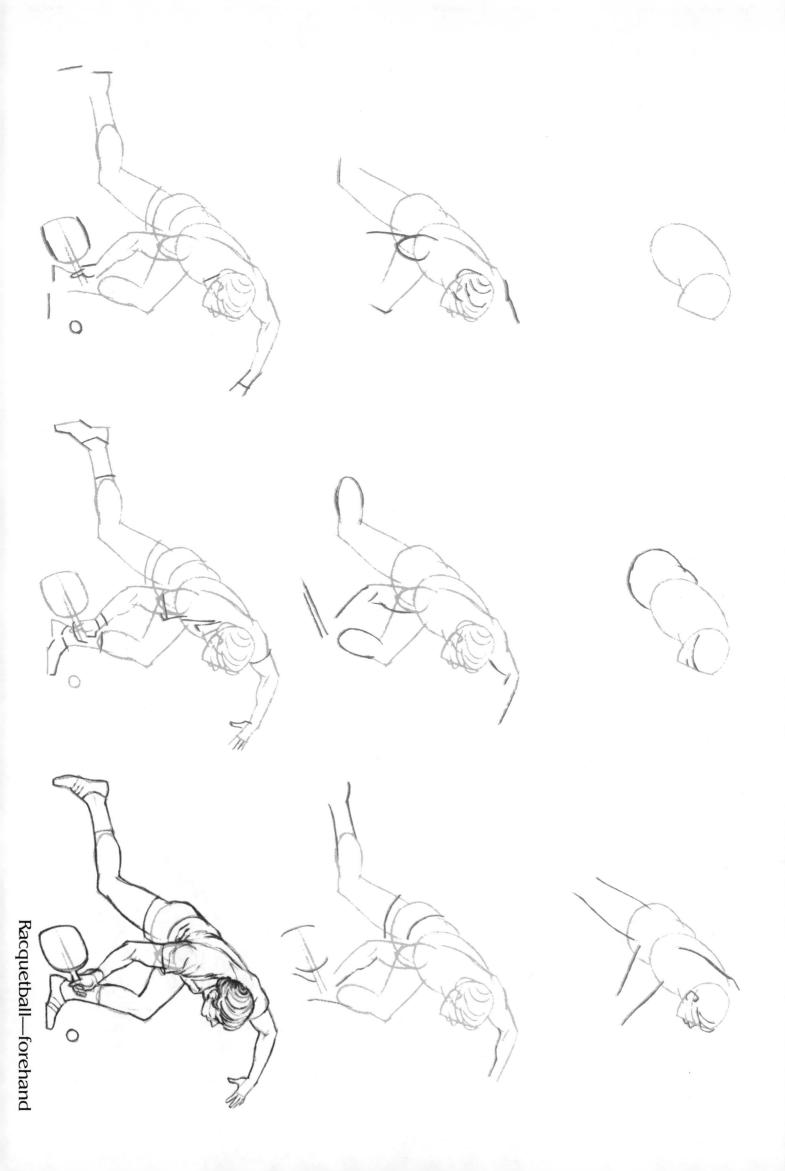

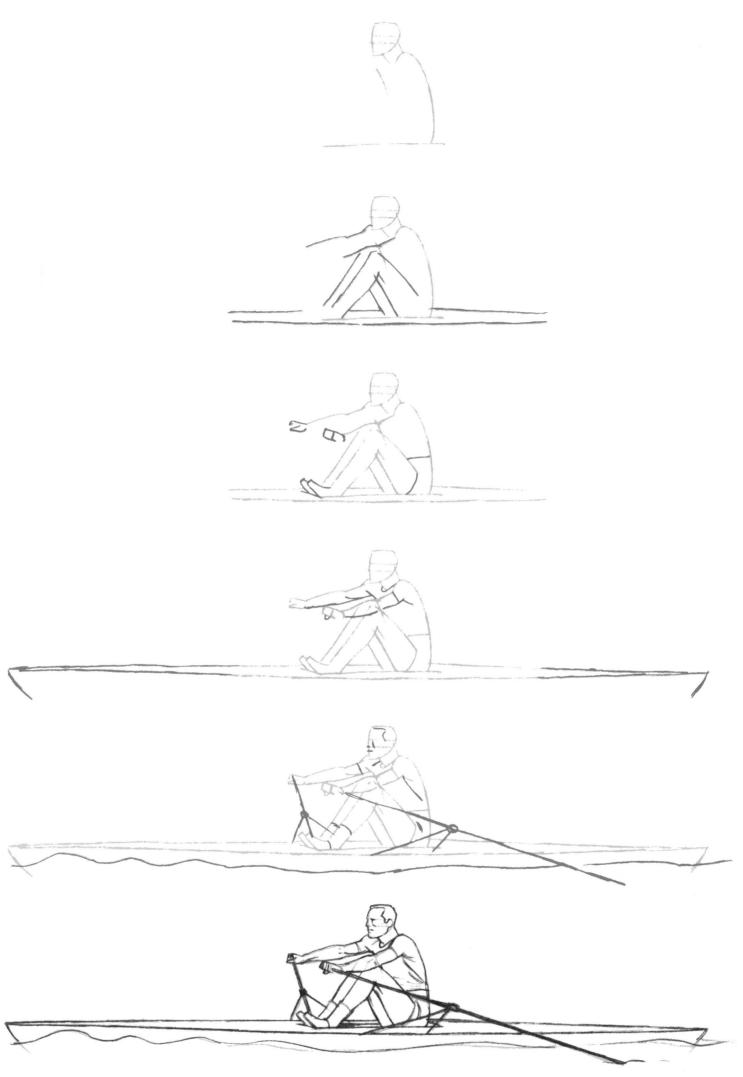

Sculling

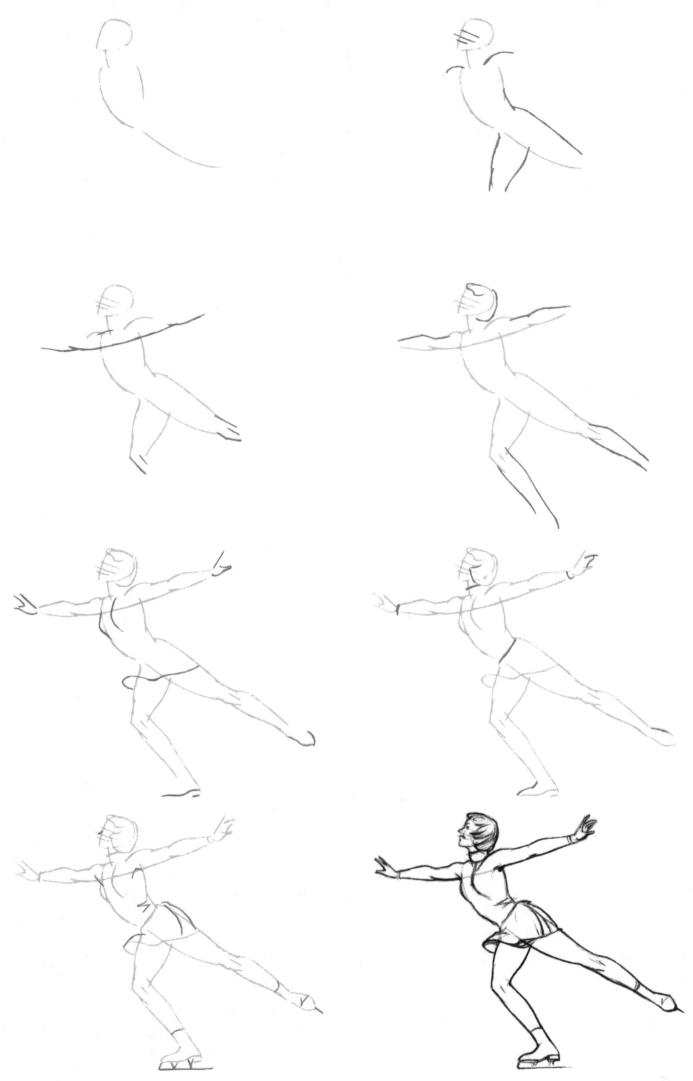

Figure Skating

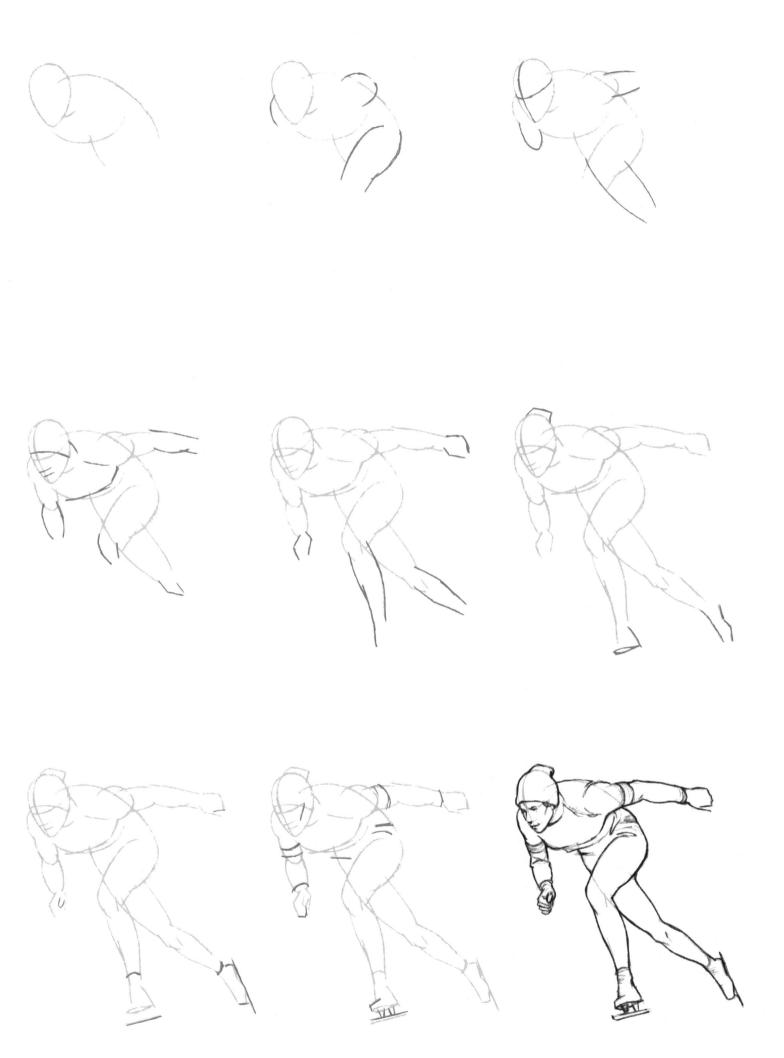

Skating—speed

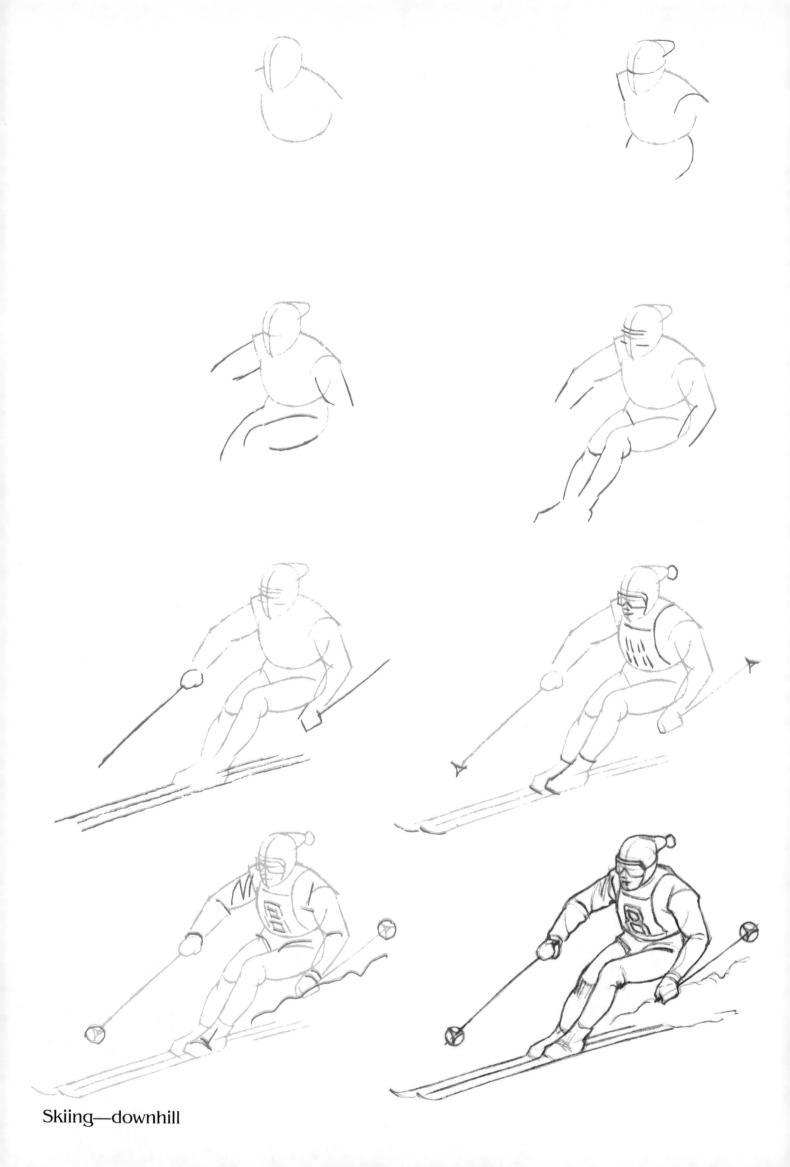

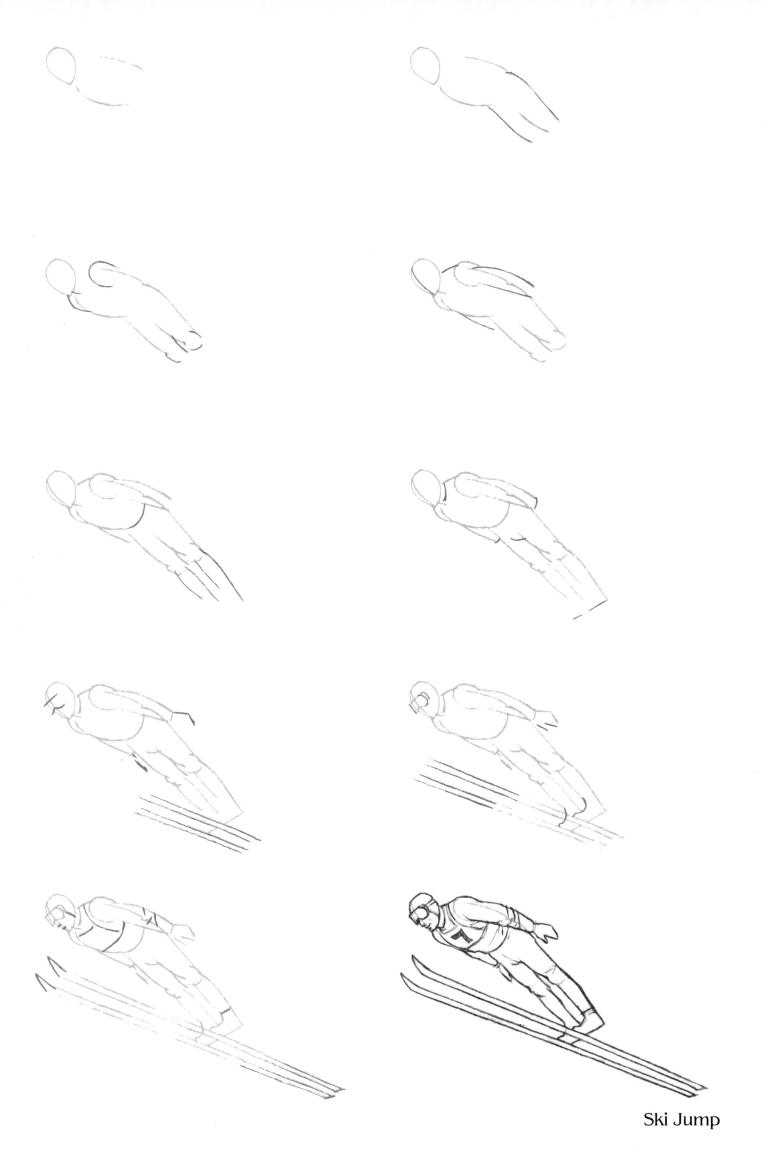

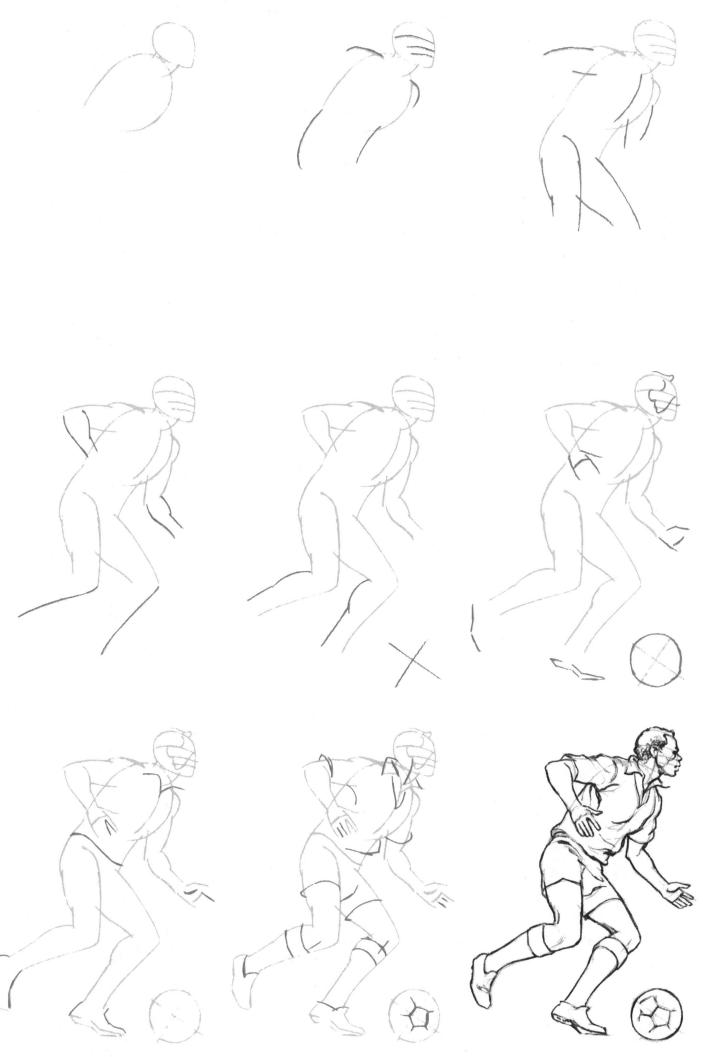

Soccer—dribble

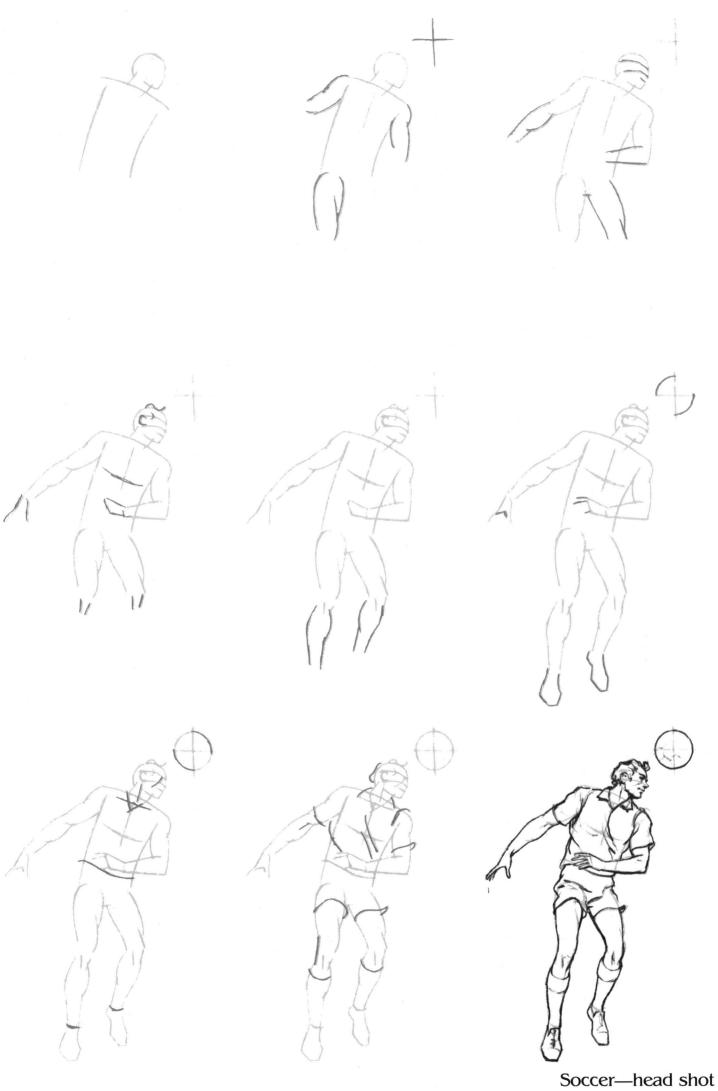

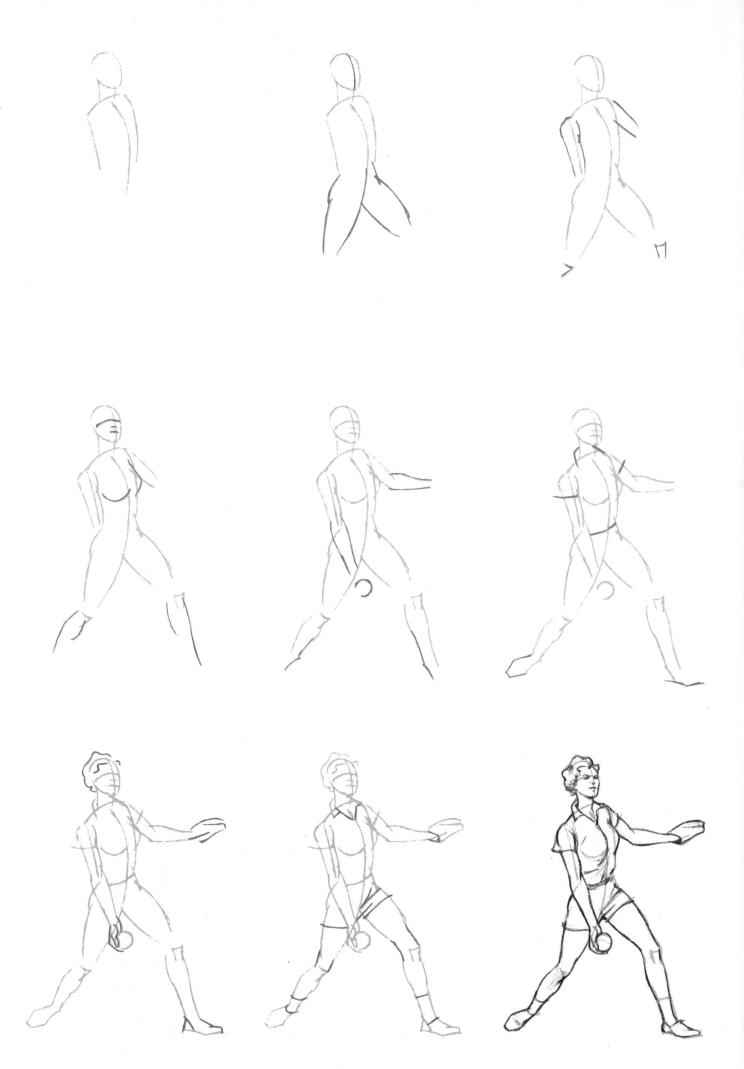

Softball—pitcher

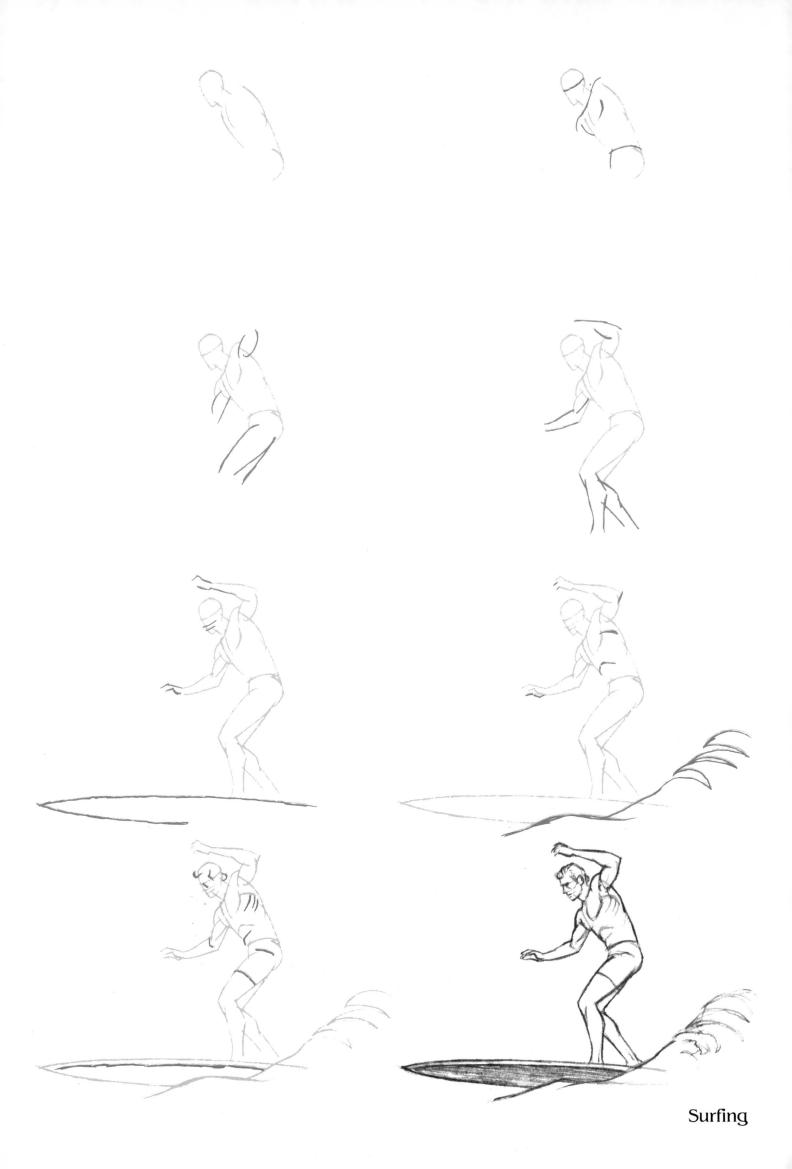

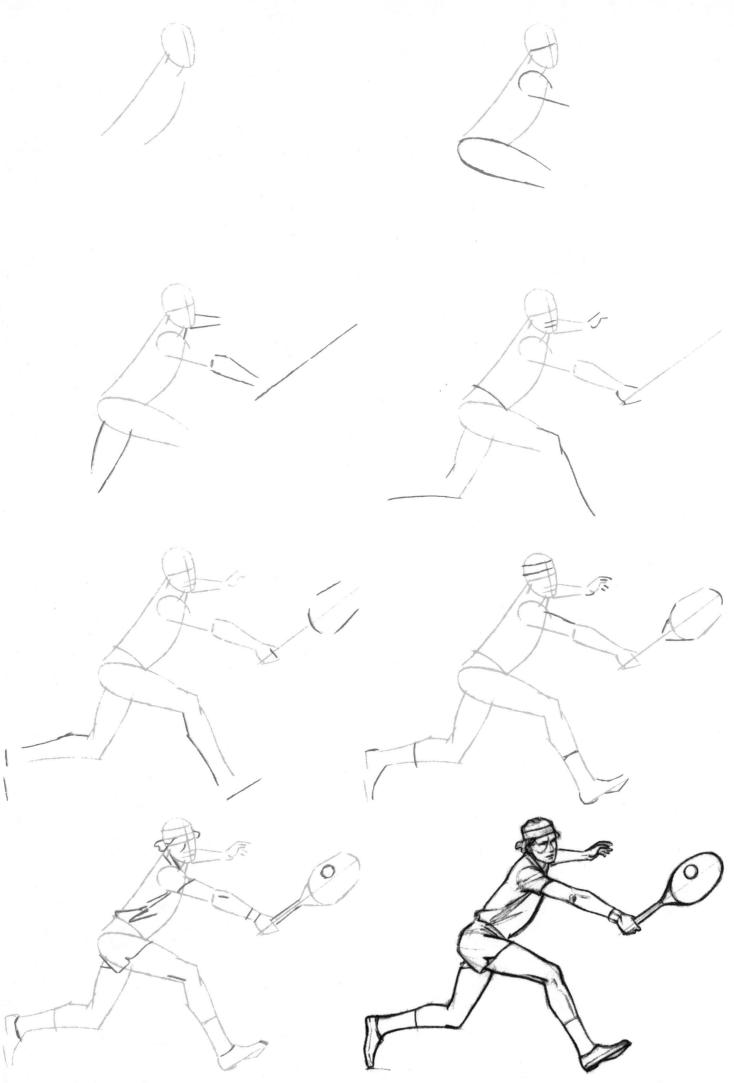

Tennis—backhand

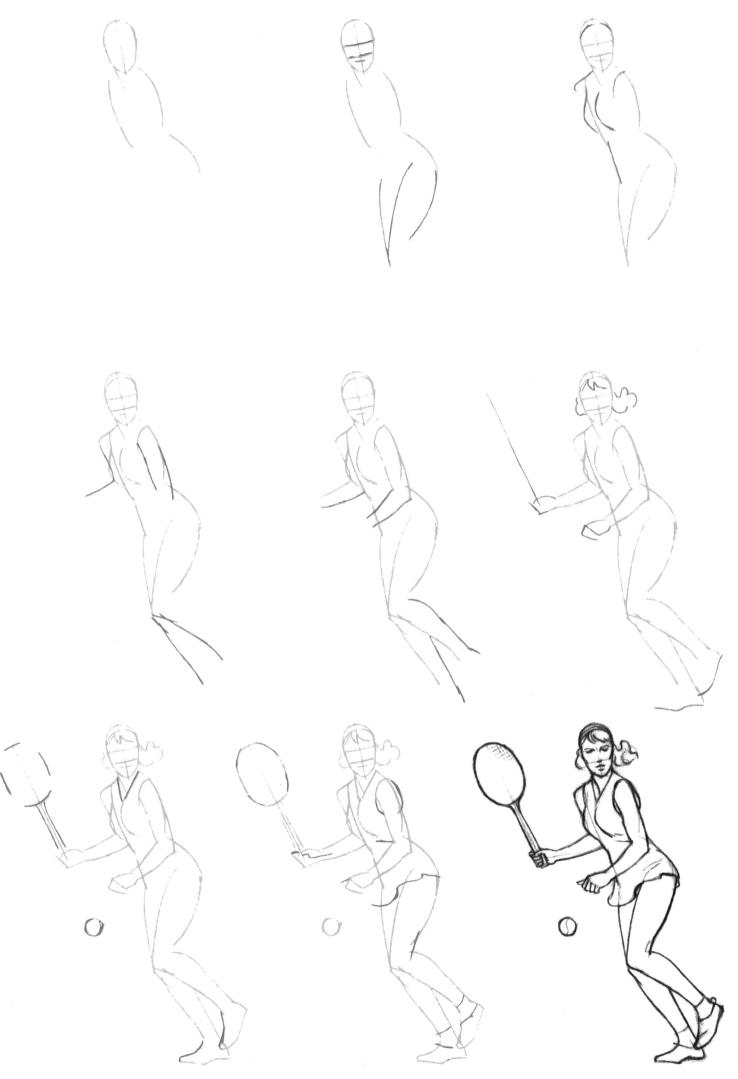

Tennis—forehand

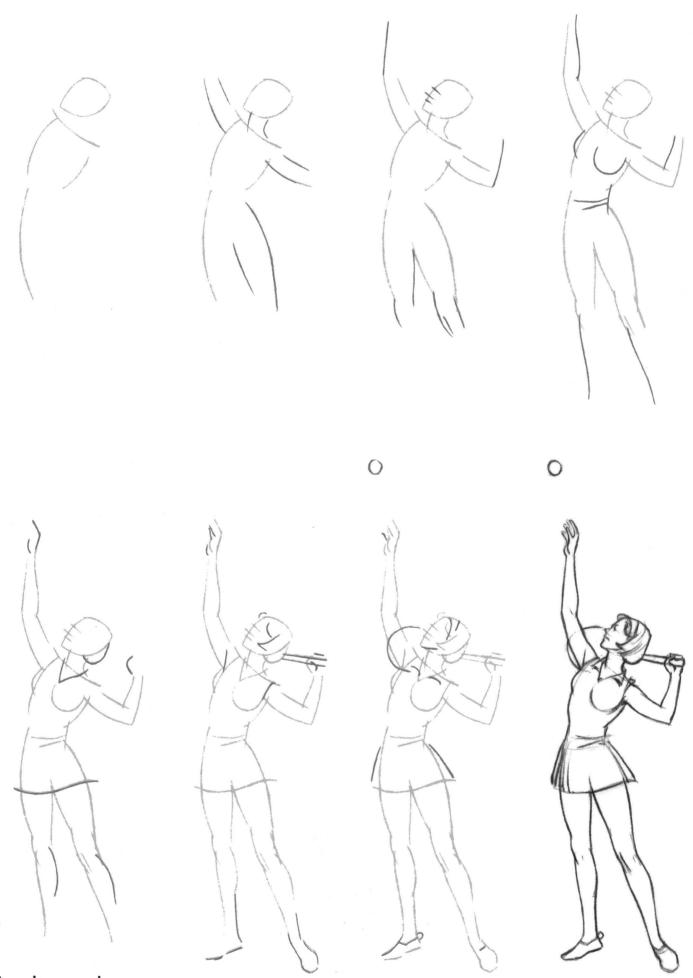

Tennis—service

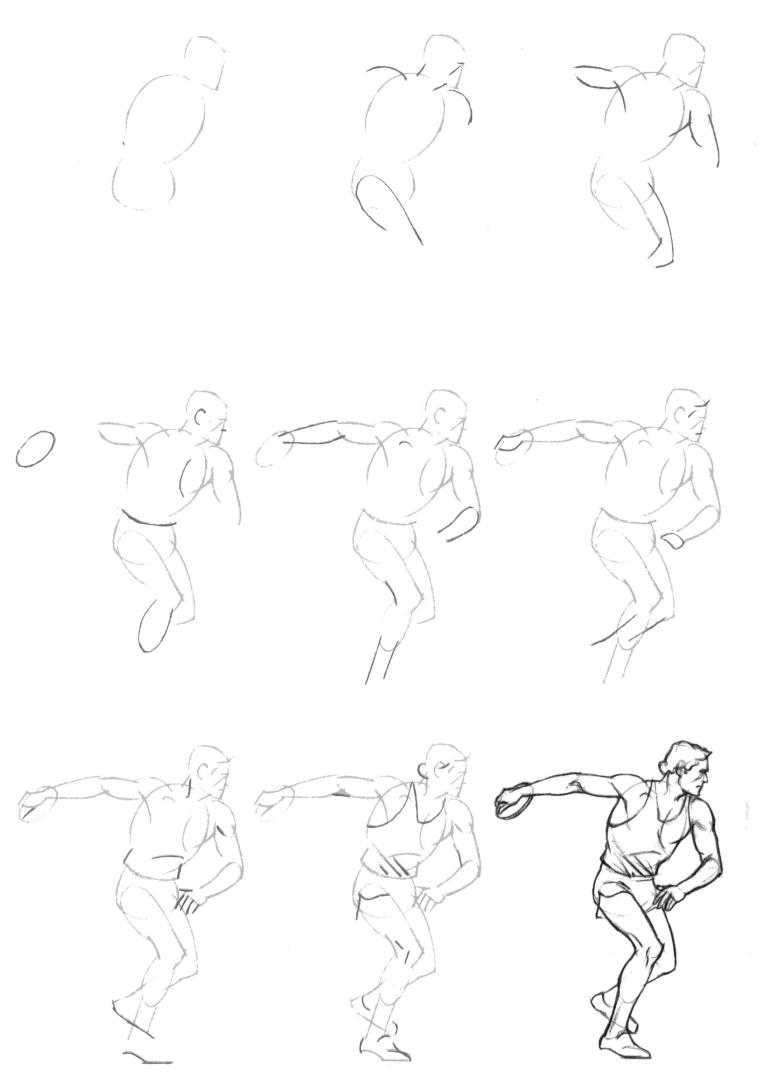

Track & Field—discus

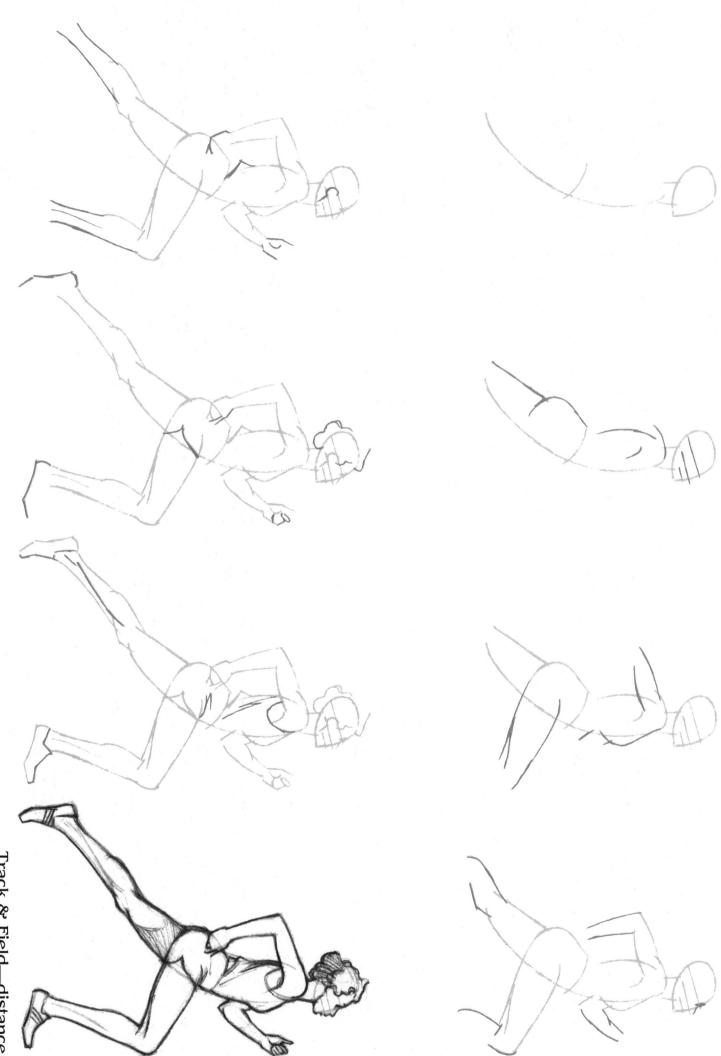

Track & Field—distance

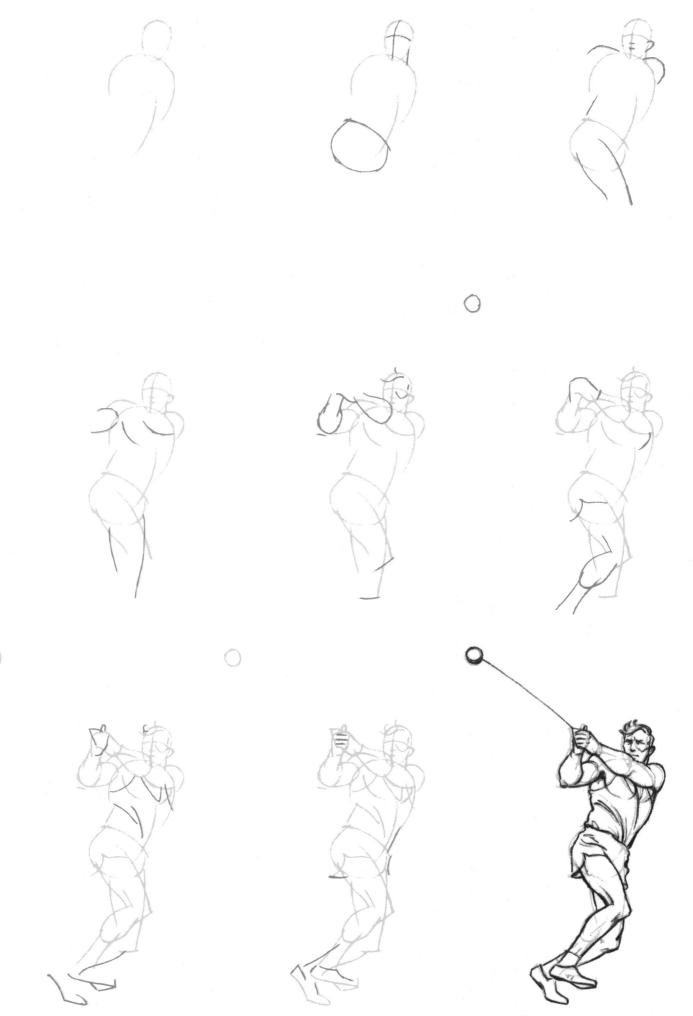

Track & Field—hammer throw

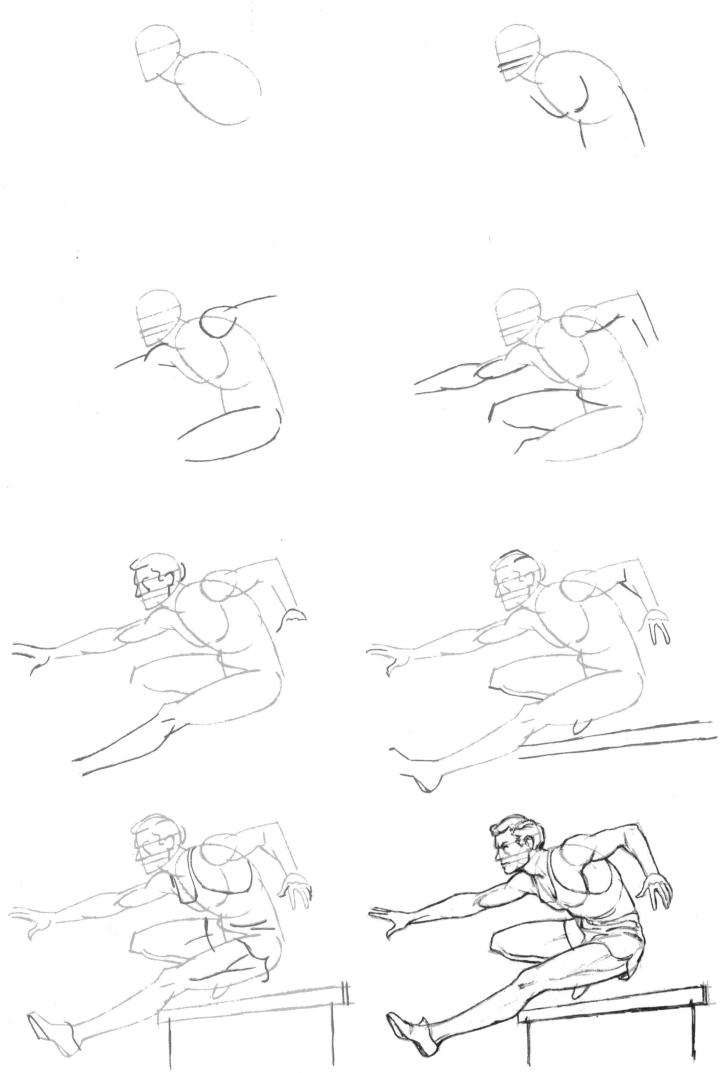

Track & Field—hurdles

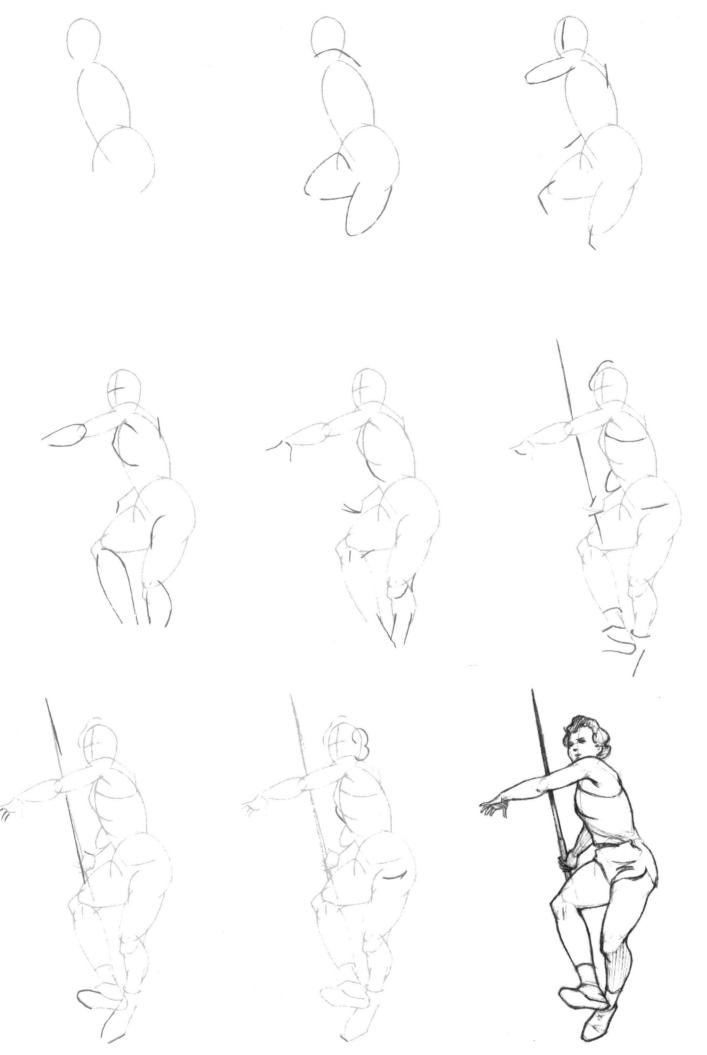

Track & Field—javelin

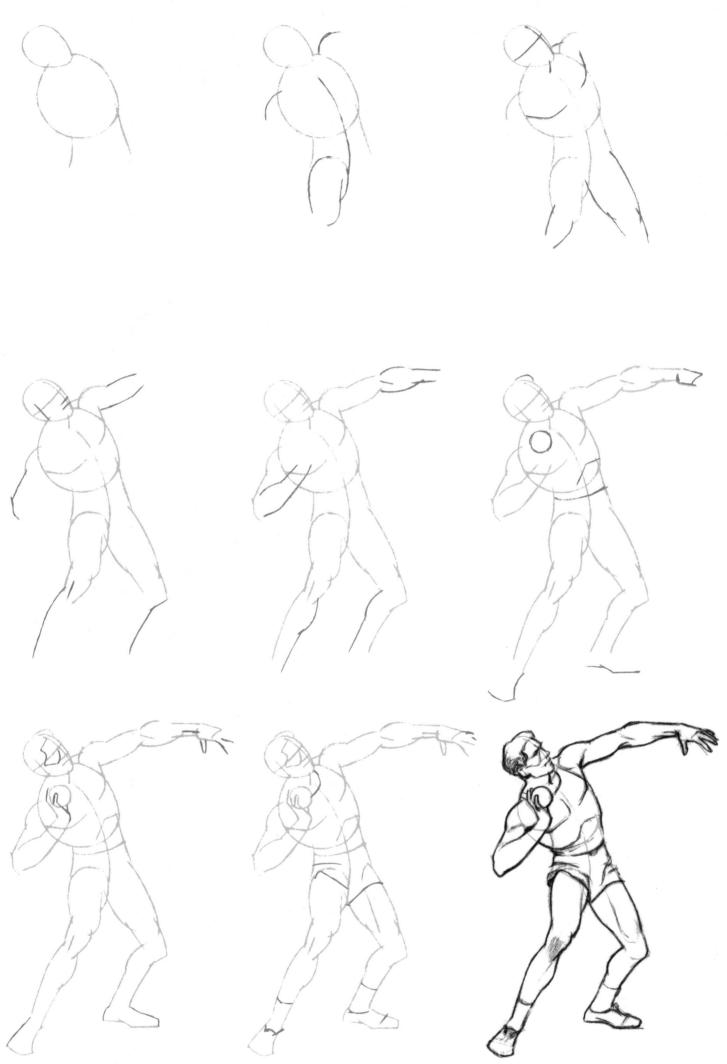

Track & Field—shotput

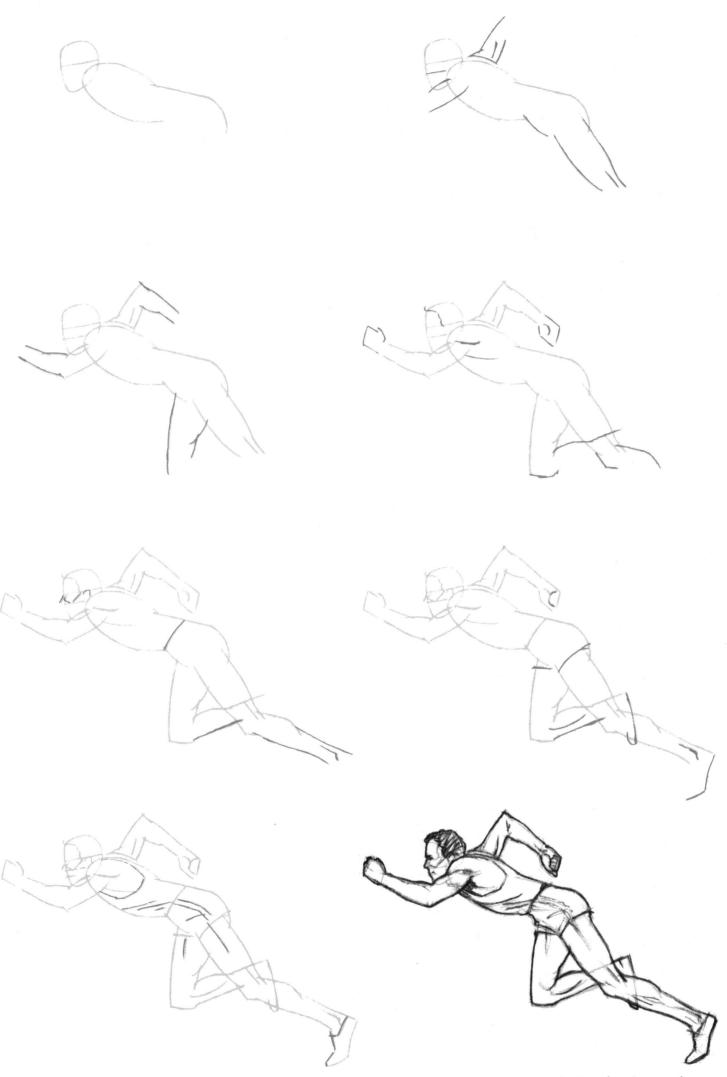

Track & Field—sprinter

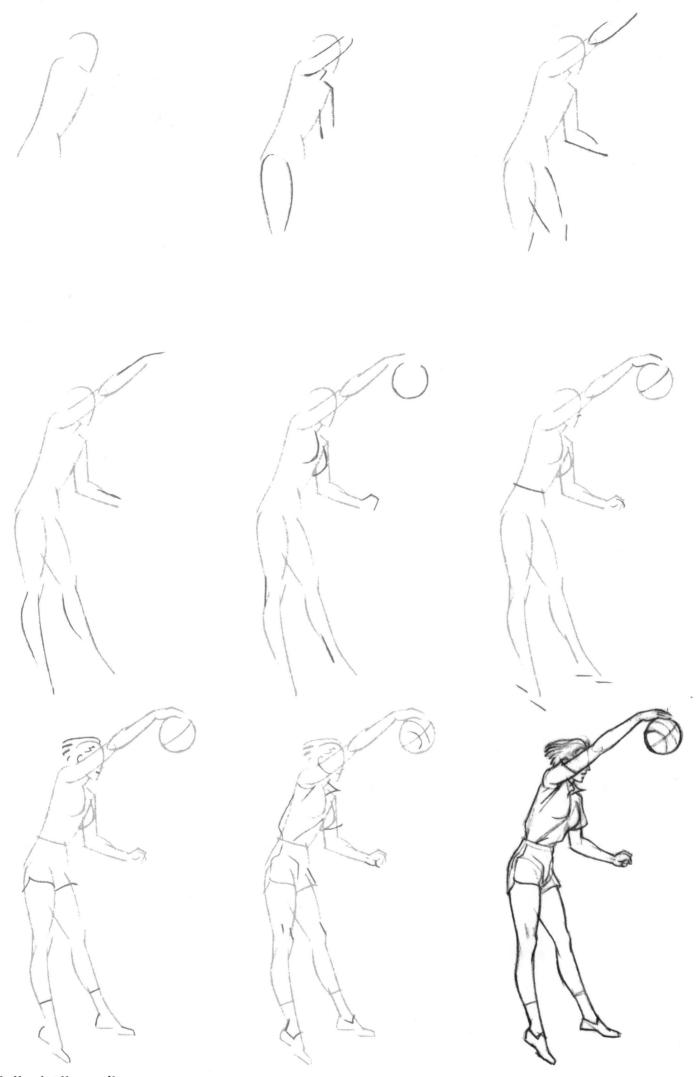

Volleyball—spike

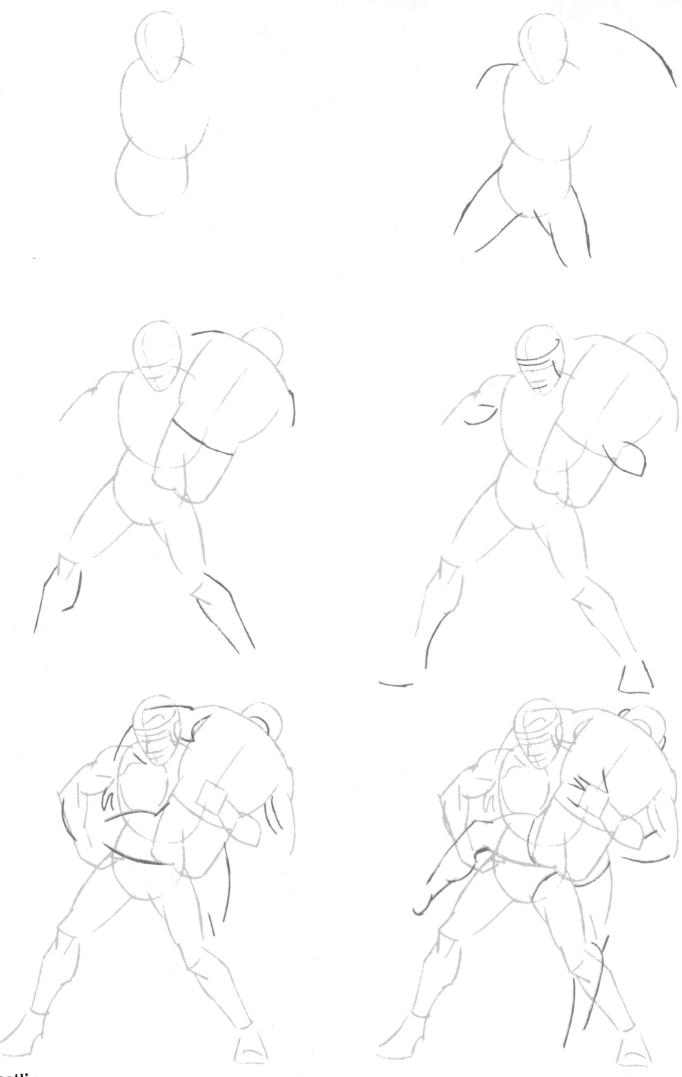

Wrestling

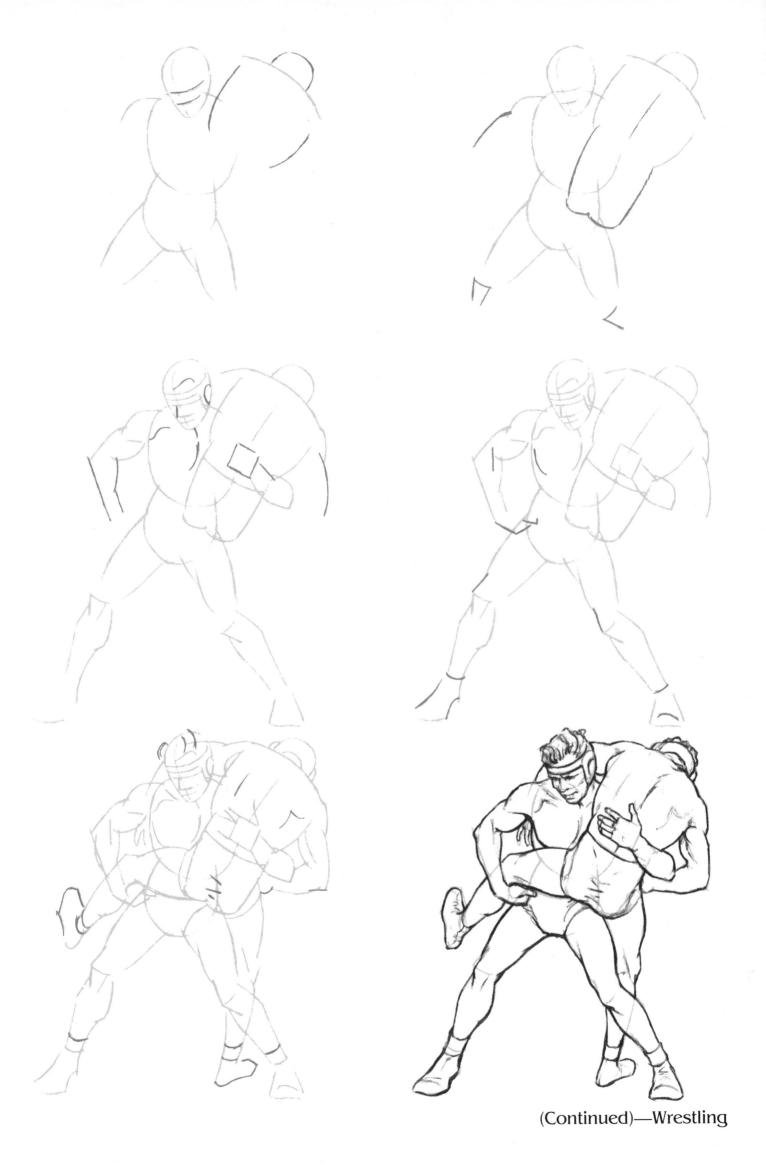

Lee J. Ames has been earning his living as an artist for almost forty years. He began his career working on Walt Disney's *Fantasia* and *Pinocchio*. He has taught at the School of Visual Arts in Manhattan and, more recently, at Dowling College on Long Island. He was for a time director of his own advertising agency and illustrator for several magazines. Mr. Ames has illustrated over one hundred books, from preschool picture books to postgraduate texts. When not working, he battles on the tennis court. A native New Yorker, Lee J. Ames lives in Dix Hills, Long Island, with his wife, Jocelyn, their three dogs, and a calico cat.

Over one million copies sold!

From fabulous felines to high speed jets...realistic images come to life from the pencil of even the most inexperienced novice with Lee J. Ames' step-by-step, learn-to-draw series. Perfect for gift-giving or collecting. Ideal for all ages.

A		
Available in		
□ 23629-8	DRAW 50 AIRPLANES, AIRCRAFT, AND SPACECRAFT	
$\square 19519-2$	DRAW 50 ANIMALS	
□ 23630-1	DRAW 50 BOATS, SHIPS, TRUCKS, AND TRAINS	\$4.95
□ 19 520-6	DRAW 50 DINOSAURS AND OTHER	\$4.0 F
	PREHISTORIC ANIMALS	
□ 23431-7	DRAW 50 DOGS	\$4.95
□ 19521-4	DRAW 50 FAMOUS CARTOONS	
□ 23432-5	DRAW 50 FAMOUS FACES	
□ 17642-2	DRAW 50 HORSES	
□ 17639-2	DRAW 50 MONSTERS	
□ 14154-8	DRAW 50 VEHICLES	\$4.95
Available in	hardcover:	
□ 12235-7	DRAW 50 AIRPLANES, AIRCRAFT, AND SPACECRAFT	\$12.95
□ 07712-2	DRAW 50 ANIMALS	
□ 19055-7	DRAW 50 ATHLETES	
□ 08903-1	DRAW 50 BOATS, SHIPS, TRUCKS, AND TRAINS	\$12.95
□ 14400-8	DRAW 50 BUILDINGS AND OTHER STRUCTURES	
□ 19059-X	DRAW 50 CARS, TRUCKS, AND MOTORCYCLES	
□ 23484-8	DRAW 50 CATS	
□ 11134-7	DRAW 50 DINOSAURS AND OTHER	
	PREHISTORIC ANIMALS	\$10.95
□ 15686-3	DRAW 50 DOGS	\$10.95
□ 13661-7	DRAW 50 FAMOUS CARTOONS	\$12.95
□ 13217-4	DRAW 50 FAMOUS FACES	
□ 15688-X	DRAW 50 FAMOUS STARS	
□ 19057-3	DRAW 50 HOLIDAY DECORATIONS	\$12.95
□ 17640-6	DRAW 50 HORSES	\$12.95
□ 17637-6	DRAW 50 MONSTERS	\$10.95
	our local bookstore or use this page to order:	
NAS .		
W 1	JBLEDAY READERS SERVICE, DEPT. LA	
P.O.	BOX 5071, DES PLAINES, IL. 60017-5071	
Please send me the	e above title(s). I am enclosing \$ Please add \$2.00 per order to cover shipp	oing
and handling. Ser	nd check or money order—no cash or C.O.D.s please.	
Me /Mrc /Mr		
1915./1911 5./1911		
Address		
City/State	Zip	
Prices and availabilit	y subject to change without notice. Please allow four to six weeks for delivery.	
	sleday Dell Publishing Group, Inc.	LA-7/88